did

u

WITHDRAWN FROM STOCK

know

An Hachette UK Company
www.hachette.co.uk

First published in the UK in 2017 by ILEX,
a division of Octopus Publishing Group Ltd
Carmelite House
50 Victoria Embankment
London, EC4Y 0DZ
www.octopusbooks.co.uk
www.octopususbooksusa.com

Distributed in the US by Hachette Book Group
1290 Avenue of the Americas, 4th and 5th Floors
New York, NY 10104

Distributed in Canada by Canadian Manda Group
664 Annette St., Toronto, Ontario, Canada M6S 2C8

Publisher: Roly Allen
Commissioning Editor: Zara Larcombe
Managing Specialist Editor: Frank Gallaugher
Editor: Rachel Silverlight
Assistant: Stephanie Hetherington
Art Director: Julie Weir
Designer: Simon Goggin
Production Controller: Sarah Kulasek-Boyd

ISBN 978-1-78157-449-2

A CIP catalogue record for this book is available from the
British Library

Printed in China

10 9 8 7 6 5 4 3 2 1

What they didn't teach you in fashion school

what you need to know to make it as a fashion designer

Jay Calderin

Contents

> **"Success isn't about the end result, it's about what you learn along the way."**
> Vera Wang

Introduction

The first thing I recommend to any aspiring fashion designer is training: without it you'll be hard-pressed to build the kind of foundation you'll need to sustain a career in the industry. That being said, even with the best of intentions you can't fit everything you need to know about being a fashion designer into a traditional school curriculum. Beyond the core skills that are most commonly associated with studying fashion design—sketching, pattern-making, and sewing—there is a wealth of information and experience that a fashion designer needs to acquire in order to have a sense of agency over the direction of their own career or business.

The purview of a fashion designer has become so complex that very few can afford the luxury of focusing all of their time and attention on making beautiful clothes. Today's fashion designer needs to build a practice. The word "practice" serves as both a noun and a verb. It describes the system you build, and how you exercise your craft within it.

What They Didn't Teach You In Fashion School is an introduction to the skills, strategies, and mindsets required to manage the making and positioning of products, services, and ideas; to cultivate and maintain a consistent flow of creativity; to continue developing professionally; to build support systems; to address business fundamentals, to negotiate the industry, to implement strategic brand and communication plans; to create user experiences, and to initiate a culture of innovation. Every chapter is intended to be used as a catalyst for further research, experimentation, and career customization.

How to Use This Book

The key to getting the most out of this book is letting go. Burst the bubble. Let go of any preconceptions you have about what will be expected of you, as well as what you may be expecting from the industry. Both will limit opportunity. Be more interested in knowing differently than knowing more. Nothing in this book is meant to serve as a "one size fits all" definitive answer. Every topic included in this book speaks to the idea that a fashion designer is an independent entity that will continue to evolve. For instance, it's just as important to see things from the perspective of an employer as it is to reflect on your needs as an employee. Being that there is so much about a career in fashion to consider— and that those considerations will change at different points along the way—the hope is that this book will serve as a source that you can return to again and again.

"Learning to let go should be learned before learning to get."

Ray Bradbury

ONE

Manage the Making

Making is at the heart of being a fashion designer. Upon completing any kind of fashion design training program, one might feel as though they've got the making part down. However, once those skills need to be put into practice—outside of an educational environment and within a working industry—it gets very real, because there is so much more that goes into it.

Entering into the process of making in this environment means having a clear idea of where what you want to do fits; an understanding that you are solving problems on behalf of other people. You will need an appreciation for the value of the sample-making process, a respect for each of the steps in the production process, and the ability to select methods for producing a garment that will best suit the situation. These skills and attitudes all take practice.

industry

"Fashion is much more collaborative than one might think. You have to have an idea and vision, and you have to communicate that vision to a team of people, and you have to create an environment that allows those people to give the best that they can give."

Tom Ford

Hierarchy of Makers

Where You Stand

Knowing where you stand in the industry is the first step. This involves more than an assessment of what you can do. Albeit with varying degrees of proficiency, most fashion designers entering the industry do so with the ability to conceive of, plan, and make a garment. Gauging where you fit in the scheme of things requires an understanding of how you want to do it, why you want to do it, and who you want to do it for.

Answering these questions provides a reality check, as well as some direction. Not everyone is suited to the corporate environment of a major brand, and starting your own business is not always an option. There is also something to be said for retaining your amateur status. If an unrelated second job helps make ends meet, you're in a position that allows you to do what you love on your off-hours, and on your terms.

There will always be a place in the industry for freelancers who can take on project-based work, and shift easily between different categories and concepts. Freelancers are becoming more important as companies begin to go lean and bring in talent on a project-by-project basis.

Another alternative to the single-job track is the portfolio career. Or, in the case of business ventures, the serial entrepreneur. A portfolio career relies on investing time, talent, and resources in a varied but related set of jobs that allow the designer to reach their audience in different ways. In addition to developing a collection each season, a fashion designer might also play to other strengths by serving as a guest editor for a magazine, designing costumes for the theater, writing books, and/or photographing editorial campaigns, just to name a few. Likewise, a serial entrepreneur builds a portfolio of diverse projects to invest in.

"In a machine age, dressmaking is one of the last refuges of the human, the personal, the inimitable."
Christian Dior

Career Path

Before applying for a job in fashion design, you must spend the time required to do your due diligence. Investigate the companies, the kinds of jobs, and the requirements of each position that interests you. This becomes the basis for every choice you make toward getting your foot in the door. You will find guides, templates, and all sorts of advice on resumes, portfolios, and interviews online. That's the easy part. The hard part is tailoring it all to each prospective employer. Each nuanced choice of how you engage with an employer can make the difference between getting the job and never hearing from them again.

What you can offer as an individual is certainly valuable, but remember that you'll be joining a team with an established dynamic, a unique culture, and a distinct set of goals. For yourself as much as for the company in question, you want to be sure it will be a good fit. Company websites and professional media channels like LinkedIn can be useful tools in your quest to gain insight into the companies you're interested in and the people you could be working for.

Degrees, certificates, and other academic credentials are prerequisites for some positions, while a body of work and the right connections are the key to others. If you've built meaningful relationships with teachers they may be able to provide recommendations and, more importantly, introductions. School placement offices and connecting with fellow alums working in the industry could also be a useful resource. Beware card-collecting exercises in networking. The true value of networking is building legitimate relationships.

Once you're on the job, being clear about the chain of command is essential. Figure out how directors, department heads, and managers operate. What are *their* goals? What do *they* expect from you? And although you can discover a great deal from the interview and training, getting to know your boss is a long-term, day-to-day process.

Mapping the arc of your career can be much like answering questions that help you define a good business plan:

- What are your long-term goals?
- How do you plan to achieve them?
- Who are you engaging to help you reach each objective along the way?
- What are you offering the marketplace?
- Who is your audience?
- What other companies are doing what you'd like to do?
- What gives you a competitive edge?
- How will you promote yourself?
- How would you measure success financially?

Entrepreneurial Track
Fashion designers who set out to work for themselves need design and business savvy in equal parts. Design-dominated endeavors that don't have the benefit of a solid business foundation put the designer in a precarious position. On the other hand, businesses that let the bottom line dictate creative decisions undermine the very reasons most designers choose to work in fashion. Maintaining this delicate balance is the primary reason for developing specific strategies that will drive your brand in the desired direction.

One of the most exciting aspects of being an entrepreneur is the opportunity to explore uncharted territory. Adopting the role of pioneer is a powerful motivator because it stirs passions and tempts us with the promise of the unknown. Playing it safe is not a common trait among those who choose to put themselves on the frontline of fashion.

Entrepreneurs are always launching. They launch ideas, prototypes, fundraising initiatives, production runs, and promotional campaigns. Whether these launches are internal or for public consumption they speak to the spirit of entrepreneurship. Every step is acknowledged and celebrated because something new is being ushered into existence. At least it feels like that way in the best of circumstances. This becomes especially useful in providing tangible deliverables designed to keep investors, employees, and the media engaged throughout the life of the project.

Any kind of startup business demands risk, if there is to be any reward. In fact many industry veterans consider the risk so high that they advise against recent graduates launching their own brands before they have a proven track record and access to the kind of money that would give them a fighting chance.

Design Thinking: Solving & Serving

Language of Design
Before you can truly employ design thinking you
need to speak the language. The language of design
is primarily non-verbal and often comes down to
working with symbols. In creating those symbols—
whether they take the shape of a logo, a garment,
or an entire collection—ask yourself if a particular
combination of colors, shapes, and textures has the
desired impact. Is it delivering the intended message?
Is the message universal or crafted to speak to a
specific audience who is in the know? Can the symbols
be misinterpreted? Do those symbols scale?

There are also very practical reasons for learning
to speak the language of design with fluency and
precision. Unlike an illustration that has the power to
capture the imagination, sketches, diagrams, technical
drawings, or storyboards designed for industry use
allow you to convey specific information about the
development of your concept. Even a toile can be a
way of sketching out an idea in three-dimensional
form before developing the production pattern.
When these visual communication tools are rendered
with great attention to detail they can help bypass
any barriers that would the delay the process or lead
those involved to misinterpret the objective.

Drafting a pattern is the next step in describing how
to transform an abstract idea into a concrete product.
Standards for this kind of blueprint vary from designer
to designer, workroom to workroom, and factory to
factory, so precise and comprehensive information
must be incorporated into each pattern. Beyond
their use as a template to cut the pieces of a garment
from cloth, they are instrumental in the grading and
marker-making process when production moves
beyond one-offs.

Considering how much work has gone into the development of a product up to this point the final stage of production—putting it together—may seem deceptively seamless. Here too, a step-by-step plan must be designed to communicate with those who will take on the task of constructing the garment. The sequence of construction must never be taken for granted, and in some instances special instruction in techniques specific to the garment may be required as well.

Serving End Users

"The customer is always right." Are they? Always? This was the message touted by companies that tried to impose the assumption across the board. But the concept has been abused by the consumer, and only large-scale companies can afford to take the hits associated with such abuses of this maxim. Small businesses can be driven out of business by adopting uber customer-centric policies that undermine more reasonable business practices. It might still be a mantra to some customers, but smart brands work hard to manage expectations and are more interested in earnestly engaging the consumer than complete surrender.

It may be slow to change but fashion is moving past the industry's perception of an ideal consumer and responding to the needs of real ones. Instead of focusing on the limitations associated with different body types, the elderly, or people with disabilities, designers can choose to approach them as opportunities to develop more human-centered design for all. Although specialty industries provide functional solutions for anyone outside fashion's current scope, fashion designers are in a unique position to quench the very human thirst to express oneself and feel attractive.

What do customers want? With the exception of a few rare birds of fashion—the irrepressible Iris Apfel for one—they want to be different, but the same. They don't want to look like everyone else, but they do want to align with the tribe or tribes that they identify with. So you need to know which style tribes are you designing for? If you can identify the characteristics of their traditions and customs, and who their leaders are, you put yourself in a unique position to serve their yearning to express themselves and have a sense of belonging.

There is limited room for form without function in a society that as a rule prizes comfort above all things. Consumers may indulge in the occasional garment or accessory with no other purpose than adornment but ultimately the foundation of an ensemble or wardrobe fulfills practical needs. A segment of the population buys into fashion fantasies and aspires to lifestyles other than their own through what they wear. They also use fashion to reflect their position within a community. The desire is not always about striving to project the appearance of wealth and status above your own. For some, adopting the trappings of a more austere lifestyle belies their position and satisfies a desire to be seen in a different light.

Fashion has a long history of being used to make statements. Those messages may express personal choices gently, as in the case of someone who chooses not to wear fur, or boldly in instances when a fashion uniform is linked with a provocative or political issue. How clothing is worn also has a voice. Sagging pants for instance has become a rejection of the mainstream. A designer doesn't have control of how the clothing they design is worn but being aware of how people are interpreting their clothing could provide new approaches to their work and how they show it.

Introducing ideas, particularly ones that challenge conventions, can test the resolve of any fashion designer. Pushing or crossing boundaries will always find an audience that is hesitant or unreceptive, if not completely in opposition to the designer's vision. Although the industry is built on a fast-paced cycle of change, the relationship our minds and bodies have with what we wear is not easily reconfigured. The courage of a designer's convictions must be bolstered by a frame of reference and passion if it has any hope of dissipating the discomfort associated with change.

Prototypes

A Good Fit

The time spent developing a pattern is one of the most valuable investments you can make. Good patterns are the result of informed decisions not default ones. Patterns also benefit from multiple rounds of modifications as they relate to fit. Fit models are crucial during this process for several reasons: The designer is able to get valuable feedback regarding the experience of wearing a garment. Designers are also able to work with a model who has the measurements and proportions of the company's target customer because sizes are not equal from brand to brand.

Fit is not relative but the experience of it is. Some people prefer a close fit while others opt for more breathing room. The style trends of the day also factor into how fit is perceived. In either case, ease plays a major part in providing the range of motion expected from the resulting garment.

Stretch has been woven into many fabrics in an attempt to address the demands of active lifestyles. This can be interpreted by some as a way to circumvent the need to develop patterns with a more accurate fit—a little stretch can be very forgiving, hiding a multitude of sins both for the customer and the designer.

Most designers land in the general vicinity of a size but standards can vary greatly, as do body shapes. For most customers getting the perfect fit means a trip to a tailor. With that in mind a designer might want to consider how their choices regarding things like seam allowance and lengths could make it easier for the consumer to customize their fit. Perhaps womenswear should adopt sizing strategies from the world of menswear—measurements not sizes. *¡Viva la Revolución!*

"To create something exceptional, your mindset must be relentlessly focused on the smallest detail."
Giorgio Armani

Performance

Performance textiles are an exciting new resource that allows the designer to build function otherwise not possible into their designs. The technology used to create this category of materials should always be carefully researched. Beyond the special properties these fabrics have to offer, the cost of making them and their impact on the environment are just two of the factors that need to be considered.

Reinforcing the architecture of a garment is another way to improve performance. If a garment is designed to defend the user from the elements, what issues are specific to weather conditions? If a garment is designed for active pursuits, will the fabric, seams, and closures survive the stress of repetitive or extreme movements and regular washing?

The maintenance of a garment is a long-term concern and cannot not be taken for granted. Testing methods for cleaning, pressing, and any kind of chemical treatments allows the designer to see where the materials or the design fall short.

In the end, the specific set of choices a designer makes about a garment will determine its lifespan. Every test and every decision comes with a monetary value and ethical dilemma. To be disposable or not to be disposable—that is the question.

specific

standards

Quality Control

A designer is charged with the responsibility of setting standards for the materials and methods being used to produce their garments. This set of specifications can be used to check the production process at any stage to assure quality throughout. Investing in high-grade fabrics and production methods is a good place to start. This initial expense contributes to the caliber of a garment, but the management of those materials is just as important. A designer or their representative follows through by participating in regular product testing and operational inspections designed to maintain standards.

In addition to a thorough system of checks and balances, the free flow of information is vital to maintaining quality. Tech packs, spec sheets, photographs, sketches, digitized patterns, samples... As a rule, the more information, the better. Additional instructions in multiple formats (written, illustrated, and video) can also be useful.

Forming close relations with sample-makers, workrooms, and factories, both in domestic situations and overseas, will help improve communications and increase the probability of successfully replicating the processes involved in making the garment and maintaining consistent quality.

Identifying mistakes and missteps along the way is inevitable. Every iteration is a learning experience and an opportunity to improve the product. Designers should also set out clear directives for how mistakes will be addressed and by whom. This is less about blame and more about who takes responsibility and compensates for any situation that results in lost time and money.

production

Manufacturing

Cutting is usually the first step in the process of making a garment. But before you start to trace out your pattern pieces and cut, be sure the goods are ready to perform in the way you want them to. This may be as simple as prewashing cloth to identify any issues with shrinkage and colorfastness, or to achieve a specific finish before construction. In many cases fabrics will already be flame-retardant, water-repellent, waterproof, mercerized, or anti-static, but in some cases those features will be added to a fabric by the designer. Blocking may be required for weaves that have warped in storage to correct the grain lines. You may wish to add decorative surface textures like embroidery, beading, or pleating to pieces prior to assembling the garment.

Stitching the garment together requires a clear plan for the materials and techniques which will be used and the order in which the pieces will be put together. This ensures that finished garments will be consistent and that missteps can be easily identified and addressed. The designer decides what kind of thread will be used, what needs to be reinforced with interfacing, how and where the garment will be lined, and what types of stitches, seams, and closures will be used.

finishing touches

The production run starts to wrap up with any hand-sewing requirements, hemming, and pressing or steaming. At this point, the garment is becoming the product that the consumer will come into contact with, so the quality of these finishing touches is essential to making a good first impression. No matter how well something has been made, if it has not been pressed properly or has a twisted hem, those are the kinds of details that begin to devalue a garment.

Once garments are complete and ready for delivery, how they are packaged, the materials used to pack them, and the method of delivery come into play. This is also the stage in which hang tags and any other pertinent branding collateral are attached. Whether something is folded or put on a hanger makes a big difference. Will the garment be pinned or clipped in any way? Did the designer include lingerie straps? Or hanger straps to hang the garment properly? And are they removable? Some customers hate them. The practical, economic, and aesthetic value of plastic bags, tissue paper, and boxes are also important considerations.

Production Partners

Throughout the entire manufacturing cycle a designer must establish relationships with various professional product and service providers in order to close the loop between themself and their clients. It will start with sourcing, and it's rarely one-stop shopping. A designer will have to do the research and leg-work to find the ideal set of vendors.

At a certain point you will rely on others to produce samples, either because your operation is scaling up, or because you need skill-specific support. Finding a person or team with as much if not more experience as you is key. The sample-maker doesn't just assemble the garment, they are a partner in the problem-solving aspect of developing each new prototype because every sample needs to be reviewed and inform any modifications that will made before production on a larger scale.

A designer would partner with a factory for when large-scale production is required, but many factories provide additional services. Shipping is one of those areas. Manufacturing overseas will demand that a designer is well versed in the requirements involved in international exchange such as customs, labor conditions, quality control, and inspections.

Identify your criteria for a good match when it comes to vendors. Start your online research using needs based keywords like lead time, repeat orders, samples, swatches, services, minimums, quality control, scale, delivery timelines, terms, imports, craftspeople, distribution, shipping, and sustainable and ethical practices. Don't overlook old fashioned word of mouth. Leverage all your contacts, and their contacts in your search. Vetting your shortlist based on price, reputation, stability and location is the next step. Remember that things change. Have backups.

Scaling

Access to resources can dictate the scale at which a designer does business. Making single one-off pieces may seem like the most affordable approach when you are starting out; however you should bear in mind that there is often a higher level of expectation when it comes to measuring the value of one-of-a-kind garments. There may also be a greater demand on the designer to generate new ideas, and devote time in regard to customer service.

A project-based model allows designers to create limited-edition collections. A designer can work at their own pace and choose to build a collection based on a theme, rather than being dictated by the cycle of seasons. These capsule collections may vary in size and scope but can create a sense of urgency in the consumer because of their limited availability. They also have the potential to become highly collectible in the long term.

Producing products for a niche market on a larger scale and on the industry's timetable will require partnering with an operation that is able produce small runs on a range of products. The size of the orders may be smaller than mass-produced runs, but the distribution points may be greater and more varied.

Mass production is concerned with serving a composite customer—the general public. Issues associated with manufacturing at this level include building a buffer into sizes to accommodate different body types in every size, increasing fabrication choices for different markets (finding more affordable alternatives of raw materials, simplifying production techniques, and delivering on high-volume orders), and being in a position to absorb losses on returns or chargebacks.

Models & Methods

Old Models

In fashion the word "couture" is used to describe high-end fashion that is made primarily by hand. It is considered to be the peak of the profession as it pertains to the level of creativity and quality of workmanship. When using the word couture, it is important to remember that it references *haute couture*, which is a term that has legal protection in France. It is the jurisdiction of Chambre Syndicale de la Haute Couture Parisienne which determines who may call themselves an *haute couturier* in France, based on strict standards. And whether or not you believe Paris to be the fountainhead of all fashion, the term has great historical significance within the industry and should be respected as such. Most fashion students learn this in school, but considering how often that term is casually tossed around, it bears repeating!

When a garment is tailored to the individual it is referred to as "bespoke." These made-to-order items usually incorporate details and special features that are specific to the needs and desires of the client. Normally associated with the kind of fine tailoring you'd find on Saville Row, there is a growing number of designers offering customization in the tradition of tailors and dressmakers.

Ready-to-wear or "prêt-à-porter" is any category of clothing, from fast fashion to luxury goods, that is purchased off the rack. It used to mean that quality and customization would be sacrificed for quantity and convenience, but technology is leveling the bar on both those counts.

While a make-do-and-mend approach to fashion used to be considered in the sphere of the crafty and practical home-sewer, it has become a design category of its own. It provides a built-in source of

"Luxury is in each detail."
Hubert de Givenchy

inspiration and speaks to a growing desire to reduce our impact on the environment by reducing waste. Designers adopting this approach set out to creatively refashion clothing and repurpose materials in what is called upcycling.

Every traditional operating model in the industry serves a segment of the population. Each has its own set of rules, risks, and rewards. Understanding these models is important but they should not be restrictive, and the introduction of new methods will always be challenging inherited notions.

New Methods

Some of the most interesting things happening in fashion are not coming out of traditional fashion ateliers, but are being developed by scientists, engineers, and computer programmers. Fashion is increasingly taking direction for the future from these fields. Although most of these new concepts are barely into beta testing (at the time of writing), new tools and materials that promise to expand a designer's toolbox are being explored and invented.

The future is now and our approach to designing fashion has several new frontiers to choose from or combine. On the mechanical front, robotics are playing a big part in the automation of knitting and weaving technologies; the construction process is also becoming more fully mechanized in an attempt to further streamline the process.

Some textiles that designers now have access to have been engineered to perform in different ways that serve the user. Various new fabrics can do everything such as self-clean, respond to the wearer's body or their external environment, and adopt the properties of alternative materials—coffee grounds, for example, which mask odors and are also environment friendly.

development

The development of e-textiles has taken the term "wearables" to a new level, with the potential for technology to be fully integrated into the design. Smart clothing features can be used to enhance the garment's performance or for completely aesthetic reasons. Embedded electronics can take the form of conductive threads to conduct energy or communicate information, sensors that monitor and transmit biological data, microcable solar cells to gather energy, nano generators to convert movement into electricity, and so on.

Innovative practices and technologies also help make efficient use of materials and protect natural resources, cutting down on the industry's impact on the environment. 3D printing and zero-waste pattern-making are methods of making things in a way that either does not produce waste or makes use of it. Digital printing and air-dying cut down on the use of water and harmful chemicals, while advanced recycling efforts help reclaim consumer waste. Leather and silk have long been prized luxury good,s in part because neither was available in an unlimited supply. Bioengineering now provides ways to grow both in a laboratory without harming animals or the ecosystem.

true

tried-and-

Repurposed Concepts

In fashion, eventually everything old is new again. Technological advancements may introduce new tools and techniques but the results very often reference tried-and-true aesthetics. For instance, the delicate nature of an open-work textile-like lace can now be emulated with a laser cutter. Intricate lace-like patterns can be cut with great precision to achieve a similar look in unexpected materials like leather, synthetic woven fabrics, and plastic.

The ancient process of matting down fibers and using pressure, heat, and moisture to bond them results in a non-woven textile called felt. The ability to mold felt into shapes is one of its most popular properties. Its modern counterpart comes in the form of spray-on fabric in an aerosol can. Fibers that fuse together when they are sprayed directly onto the body or a form offer even greater malleability. Not only do they bypass the need to knit or weave fabrics, but they also skip the steps involved in assembling a garment.

Many designers license or sell their designs to pattern companies allowing local dressmakers or home sewers to recreate the looks for themselves, but a new model has designers selling fashion with some assembly required. These prefab DIY kits include all the components but allow the designer to put the responsibility of constructing the garment in the hands of the customer.

TWO

CULTIVATE CURIOSITY & CREATIVITY

2

Cultivate Curiosity & Creativity

Fashion school can be an ideal place to celebrate and encourage creativity. It is definitely easier to sustain the spirit of creativity within that safe environment. What is infinitely harder to do is build systems and routines that keep us curious and help us exercise our creative muscles once we are on the job. Burnout is a very real problem in the workplace, especially creative workplaces. The fashion industry is constantly demanding something new. What do you do when it seems as though there is nothing new to give and you need to deliver on demand?

A designer who can reconnect with the essence of the experiences that called them to a career in fashion, and initiate that process on a regular basis, will build a bank of stimuli that allows them to always have something at the ready, and go deeper into these areas than they ever did in school. There are many ways back into the creative foundations for a fashion designer: through the craft of fashion, by putting theory into practice and content into context, by cultivating a sense of play, and through creative collaboration. Reinforcing our connections to these creative fundamentals will prevent them from deteriorating, and returning to them will be as different each time as we ourselves are.

build

"One doesn't want fashion to look ridiculous, silly, or out of step with the times but you do want designers that make you think, that make you look at fashion differently. That's how fashion changes. If it doesn't change, it's not looking forward. And that's important to me."

Anna Wintour

Handmade

Fashion Craft

If a designer isn't vigilant, the first casualty of working in the industry can be the craft itself. The temptation to dismiss the more involved approaches to making fashion for the sake of keeping pace is strong, but without an appreciation of the finer aspects of the craft a designer starts to deplete their creative resources. You should never take fabrication for granted: a world of possibilities can be discovered in the intricacies of warp and weft, or knit and purl.

The nature of fabrics and their relationship to the body is another playground that a designer can return to again and again. Fashion history is full of masters, both kindred spirits and challenging visionaries, who can serve as guides for exploration. While a designer like Madeleine Vionnet manipulated bias cuts of light crêpe de chines, gabardines, and satins that conformed to the curves of a woman's body, Cristóbal Balenciaga shaped stiff, heavier fabrics into bold, sculptural silhouettes and redefined the fashion of the day.

Every designer should be well versed in a few well-chosen handcrafted couture pieces. The challenge lies with the classic interpretations of old-school techniques like appliqué, embroidery, beading, passementerie, silk flowers, or feather work. Relish the ability to embellish within the boundaries of tradition, or redefine them altogether.

Whether it involves bound buttonholes or boning, the trademarks of many structurally sound garments rely on specialty skills like tailoring and corsetry. Horsehair canvas and hand pad-stitching are two of the important underpinnings of a finely tailored suit, while building an evening gown over the frame of a foundation garment can be the difference between a good dress and a great one.

"The future of fashion is handmade."
Carla Fernández

Preserving Proficiency

Surprisingly, some of the institutions designed to provide us with access to information, culture, and wisdom are the last we resort to. It seems easier and more relevant to look up something on the internet than to make a trip to a museum or our local library. Contrary to popular belief, however, not everything has made it onto Google. Also, nothing can replace peer-to-peer interactions and the kinds of insights that a curator, docent, or librarian can bring to our research. Perhaps a longstanding reputation for being the gatekeepers of old-world academia has kept us at bay. There was a time when you had to really want it to get past them. That has begun to change. Those guards are now guides who work hard to meet audiences where they are, spark their imaginations, and make them a part of the experience.

Although professionals in other fields regularly take advantage of relevant research facilities, not many fashion designers know that making an appointment with the fashion or textiles department is all that may be standing in the way of access to a museum's collection and the help of their in-house experts. Searching a museum's online databases makes it easier to narrow down the specific subjects or items you're interested in investigating. In addition to focused research, there are new ways that museums and creative professionals are interfacing. It turns out that museums can be great partners on projects designed to connect with new audiences to deliver the arts, culture, and history in ways that are relevant to their lifestyles. These institutions understand that one way to do that is to collaborate with fashion designers and other creatives to hack the traditional museum experience. Being involved in the development of innovative programming is a way to get the designer thinking differently about their expertise, while also allowing the museum to remain vibrant and viable.

Libraries and schools are changing too. In addition to being repositories for print and digital media of all kinds, libraries are reestablishing themselves as cultural hubs. Educational centers are offering programming that reflects the needs of their communities. Both of these environments, whether they focus on fashion or not, provide opportunities for a designer to explore their craft through alliances with librarians, educators, and students, as well as connecting creatively with the general public.

Visits to active workspaces, regardless of whether or not they are related to the field of fashion, can inform and expand a designer's process. Peers or leaders in fashion—or their counterparts in other industries— are often as curious about what we're doing and how we're doing it as we may be about them. This exercise is less about divulging trade secrets and more about an exchange of best practices. It can help us tap into insights and inspiration that can only be understood and appreciated by seeing them in action.

Reinterpreting Techniques
Designers all have their go-to tools and machines, and favorite materials. Training and experience make them comfortable and familiar allies in their creative practice. At the same time, consider that they might be restricting the scope of your creativity if there is an unwillingness to try new devices, materials, and methods. Introducing unfamiliar instruments is an excellent way to keep your creative options open. A designer will want to become well versed with how any new instrument works, but by no means must be restricted by its intended purpose. Repurposing a tool frees a designer to reinterpret techniques and can even lead to the invention of new ones.

Unfamiliar textiles and notions also offer a fresh take on our creative decisions regarding the raw materials we use. In addition to the growing number of innovative tech fabrics available, a designer can choose to pivot from the established materials of their niche to explore and adopt the trappings of other design categories. How might evening wear be reimagined by the use of colors, patterns, textures, and trims associated with children's wear, denim, or outerwear design, for example?

Interpretation is an integral part of what a fashion designer does. That is why they must be wary of not crossing the line into appropriation. This is true of instances in which they must respect intellectual property, but crucial when it comes to cultural appropriation. Some designers feel that as a creative anything is fair game, but designers don't work in a vacuum. Whether it's a matter of being uniformed or a disregard for cultural sensitivities, a designer's choices do have the ability to empower or disenfranchise cultures.

With that in mind, it isn't reasonable to think that designers should suppress what inspires them about the cultures of indigenous communities at home or abroad. The key to taking action on that kind of inspiration is to move beyond the superficial. A designer who makes the effort to better understand the origins of a culture and the people who live it are more apt to respect boundaries, ask permission, and approach any attempt to honor these cultures in their work with consideration.

Aesthetics: Theory & Ritual

Theory
Sometimes the only way to kick-start creativity is by getting back to the basics. Theory is one of those areas that we assume we've got under our belts once we've completed the required coursework in school, but our relationships with theories change over time as we evolve creatively and as we apply them to our professional projects. Even though theoretical considerations will most likely be restrained by budgets and challenged in real-world situations, that doesn't mean aesthetics shouldn't be explored within these traditional frameworks. If anything, the practical business demands on the designer's ingenuity should raise the creative stakes for the better.

Test your ideas against the elements and principles of design. For example, you can gauge your designs' impact in terms of color theory. What can be interpreted from your compositions of color and how you arrange them within a collection? Ask yourself how elements like line, shape, size, and texture will help you put together a strong garment. Will practicing the principles of balance, proportion, and emphasis provide a clear center of interest for an ensemble?

Over time a designer may internalize the theories that best suit their aesthetic. Although this may serve them for a while, the designer may also be closing the door on opportunities to expand their vision. Challenging yourself on a regular basis by reconnecting with core theories will help you gauge whether or not there is new territory to explore.

Methodology

Starting at the beginning means different things depending on your design approach of choice. A designer may decide to filter a concept through any one or combination of four basic design strategies: structural, functional, technical, and decorative. Each path will emphasize different things.

Structural: When it comes to designing the construction of a garment, prioritizing structural concerns involves the selection of quality materials and sound assembly methods that are right for a specific job. The designer is thinking like an architect in terms of making those choices and supervising the process that brings them together.

Functional: Designing how the garment will function relies on a clear understanding of how the consumer will use the garment. It breaks down further when you consider whether the design is providing a physical function or a psychological one. Adaptive function also comes into play when one of the primary needs of the consumer is modification of the garment's properties according to external factors. When working with integrated technologies the designer has to factor in responsive function.

Technical: Technical design bridges structure and function. Here the designer is concerned with the mechanics of utility and how it will be integrated into both the construction and use of a garment.

Decorative: Decorative design is concerned with beauty, the subjective domain of the beholder, but it can also be a key factor in successfully engaging with the consumer.

A good designer will make use of all four mindsets in measures that reflect the project at hand.

Habits & Rituals

Putting creative theories into regular practice is a good habit to adopt, but sustaining good habits does require some effort. Have a plan. Set goals, define triggers, and track your progress. Building healthy habits is not always about pleasurable experiences, activities you are comfortable with, or things that you can do well. The right habits can be very helpful in breaking through creative blocks and tackling the things that, given the choice, we would rather not deal with but know we should.

Breaking bad habits is just as important. You also need to have a plan. The first thing to do is to acknowledge what your bad habits are. Then you can work on recognizing and eliminating triggers. Be accountable, but don't beat yourself up. It is easier said than done, to be sure, but worth the effort.

Elevating routines to the level of a ritual has the power to remind us of what is most important about our craft and why we first wanted to do the work in the first place, as well as compounding good habits and increasing our pleasure in performing them. Rituals also offer us a sense of stability, and continuity. The observance of rituals will eventually become second nature, figuring into a designer's timetable like holidays on a calendar. Rituals are as much about meaning as they are about behavior. Meaning has always been a sought-after personal reward for the creative professional. It is also a very powerful element of a designer's work and valuable aspect of their professional brand.

plan

Content & Context

Creativity & Problem Solving

One thing that can be trusted to spur on creativity is having a good problem to solve. The emphasis on creativity should also not be limited to aesthetic concerns; a good designer is identifying new patterns and making unexpected connections in hops of bringing new ideas to fruition throughout all aspects of their work. Sometimes the most significant breakthroughs started out as significant problems.

When solutions don't easily present themselves, ask yourself questions about the nature of the problem: Is the difference between the cause and the symptom of the problem clear? Does this situation have the potential to generate socially responsible solutions? Gathering information is as important as the time spent processing it; it is only after having both that instincts informed by that incubation period are more apt to become clear in the mind of a designer—the "aha!" moment.

Creativity is fluid and needs a culture of curiosity to thrive. The flexibility to experiment with a problem allows the designer to broaden the scope of their investigation. Does this problem have a single solution? Or are there several ways to achieve the desired result?

And if creativity is defined by what it is trying solve, what about the authenticity of the problem? Is it a matter of perception? Does it depend on who's in charge? Who will benefit from the solution? Or does the authenticity of the problem lie with the objective observer? These questions initiate a deeper level of scrutiny, in the search for a balance between relative and real problems.

different

Creative Pitfalls

One of the more destructive byproducts of committing to create is an "inner critic," which can magnify self-doubt to debilitating levels. That kind of thinking can give rise to the imposter syndrome, when we undermine our efforts by questioning our very right to express ourselves. And being overly concerned with creating something original can become a fetish that paralyzes the creative process altogether. Ideas have little value until they are implemented so taking control of these negative influences early on is crucial.

You can challenge the inner critic by reframing the way you think about your work. Be specific in your criticisms and identify the good things as well as the bad, and set yourself goals. Bear in mind that everybody fails from time to time and that it is a good indication that you are stretching yourself. This is good: it means you're learning.

What about original content? Is it true that good artists borrow and great artists steal? T.S. Eliot wrote, *"Immature poets imitate; mature poets steal; bad poets deface what they take, and good poets make it into something better, or at least something different."* The same can be said for fashion designers. There is no creativity involved in copying an idea, as opposed to the creativity required of a designer who takes any idea somewhere new.

Designers can often be overly protective of their work or project. The pitfall of being too precious with an idea can be circumvented by editing, revising, and revisiting content in an attempt to optimize its impact, whatever shape it takes. Step back from the work itself and remember what you are trying to achieve through it.

"Immature poets imitate; mature poets steal; bad poets deface what they take, and good poets make it into something better, or at least something different."
T. S. Eliot

Authentic Play

Recreation
There is no need to sacrifice pleasure for your process. In fact, having a little fun along the way is conducive to creativity. Individuals and projects will ultimately benefit from playful periods—smiles and laughter have both been shown to reduce physical and mental stress. Time may be at a premium for everyone, but allowing a fear of interruptions to suppress spontaneity and enjoyment is erring on the wrong side of productivity. A designer who can recognize and be open to embracing timely deviations from the production schedule is investing in the creative process.

Pressure in the workplace can erode creativity. Smart employers—including the self-employed—factor in physical activities that allow everyone to let off some steam on a regular basis. The office and the workroom are environments that are full of reminders of the work at hand. A change of scenery without those constant cues is more apt to allow you to decompress and recharge.

It's also easy to forget while you're in the workspace that in the end you're a person making memories as well as clothes. Ideally they will be good ones.

> "Creative people are curious, flexible, persistent and independent with a tremendous spirit of adventure and a love of play."
> Henri Matisse

Collaborative Challenges

Beyond play for play's sake, the gamification of workplace activities is one way to combat disengagement and lack of motivation on the job. Success, even in game form, results in a sense of achievement for those who participate, especially when the challenges are tied to workplace activities. Games are not kids' stuff when you have clear objectives and encourage collaboration.

Games also have the power to change perceptions about work. They can transform dull, repetitive tasks into fun ones. A game can be designed to be a source of regular feedback. Rules with a clear path to results provide a level playing field. The stigma of failure within the framework of a game is abated by a transparent process and the focus on meritocracy.

Teamwork is an essential part of designing fashion. Playing to each person's strengths has long served fashion houses that have co-creative leads or divide the duties associated with running a brand between a creative director and the business lead. The camaraderie and lasting bonds formed by these relationships are proof that two heads are often better than one. Shared experiences also generate meaningful new reference points that become part of a shared history.

Friendly competition gets friendlier when there are multiple opportunities to succeed. Designing a game that recognizes the contributions of each division of the creative process and evolves over time will ensure that it remains fresh, establishing it as a tool that can be put to use more than once. People are motivated in different ways at different times and some games have a shelf life, so it's also important to know when introducing a game into the workplace if it's a non-starter, or when it is game over.

Creative Crowdsourcing

Sharing

Sharing in the creative process is often an acquired behavior. For some designers, soliciting the advice of others is tantamount to admitting to a deficit in their talent; however, there are occasions when getting outsiders involved, and learning to play well with others, is of great value. Specialists focus our attention on specific aspects of a project, while consultants can help an individual or team take a step back to see the big picture.

Working with communities: Participation in online forums can expand a designer's reach far beyond physical borders. Professional organizations offer members opportunities to connect around information and shared goals. Engaging with schools can provide teachers with connected learning activities, students with real-world experiences, and designers with fresh perspectives and the opportunity to spot new talent.

Working with the consumer: Inviting the consumer into the design process involves getting a product into the hands of the target audience, as well as establishing channels for collecting feedback and measures for processing observations and evaluations. There is also the very practical need to factor the designer-client exchange into the creative development timeline.

Outsourcing production: A designer may also choose to have the production of specific parts outsourced to experts in that field. In this scenario components are designed so that they can easily be reintegrated into the final design. Situations in which specialists are entrusted with this kind of work should be treated like an equal creative partnership, however brief. (See also *Production Partners*, page 26.)

Tangents

Tangents can steer us out of complacency and drive us into creativity. It's also fair to say that some departures from the plan can run us head-on into a wall. Whether switching gears means taking on a temporary projects or making a permanent pivot that takes your project or brand in an entirely new direction, some thought should be given to how you will respond to these forks in the road.

Even with the best of intentions to follow one particular path, you can leave your options open by setting up contingency plans for course-corrections along the way. The decision to get off the beaten track can be a strategic choice; sometimes the reallocation of attention, time, and resources to a side project will help you reach your intended goal in the end, and possibly with a better result.

Finding the courage to follow the road less traveled means embracing uncertainty and being willing to take a risk. Despite a natural resistance to the unknown, the setbacks and successes experienced while pioneering new frontiers and working with new people can lead to personal growth and professional development. Some creative deviations will be dead ends. The important thing to remember is that turning back is not defeat. There are always ideas that are ahead of their time, concepts in search of their match, and relationships that have yet to mature. The experience itself and whatever a designer can take away from it can be banked for future use.

courage

3

THREE DEVELOP PROFESSIONALLY

Develop Professionally

There is always something new to learn. Learning new things should feel like a calling, not a chore. However, human nature has a way of allowing us to become complacent once we feel we've put in our dues and achieved a measure of success. This can prove to be the beginning of the end of a robust and rewarding fashion career. It may not be overt, but a designer is always being assessed by their clientele, the industry, and the media. Whether it is a conscious act or instinct, designers are being judged by how they measure up against current standards.

Continuing to build a broad base of knowledge and experience is one of the most valuable investments a designer can make in their future. Being a lifetime learner should include traditional methods as well as customized learning strategies. Many fashion designers overlook the valuable inheritance that the industry provides—history. Every idea, strategy, and business model that has come before has the potential to provide a designer with the tools for advancement. Professional development also demands action. Part of a designer's job involves predicting what will succeed in the marketplace, and taking more educated risks is a distinct advantage.

risks

"Nobody cares how good you used to be."

Paul Smith

Fashion Quotient

Knowledge

Knowledge is power. When it comes to the pursuit of knowledge there are three powerful drivers to consider: The desire for knowledge can be a simple matter of keeping pace with the industry, because fear of missing out or being left behind are strong survival instincts. On an emotional level we seek out opportunities to better ourselves and share that knowledge within our personal and professional communities. Our third path to knowledge makes use of logic and reason to explore our imaginations and communicate with others. Understand how you're engaged with building your base of knowledge and you'll do a better job of being sure that it is as balanced as it is comprehensive.

The facts about anything you want to understand are out there, but they are useless until you do something with them. Collecting, editing, and organizing data allows you to put it into context and transforms it into usable, shareable information. The methods of sourcing the raw materials for that information are pretty straightforward. You can ask questions of your leaders, peers, staff, and clientele; you can read books, articles, and research materials; listen to experts; and observe successful examples over time.

Information needs to be exercised. Putting information into practice will allow you to measure how useful it is, where it needs to be edited, and when it requires further research. Only that kind of hands-on experimentation will provide you with insights into real-world applications. Being able to practice, write about, or teach that knowledge are some of the best ways of banking experiences that can be cashed in later on.

> "Don't be afraid to take time to learn. It's good to work for other people. I worked for others for 20 years. They paid me to learn."
> Vera Wang

The evolution of knowledge is wisdom. Here is where you'll find and eventually join the true experts in your field. This should be the true goal of professional development. Gathering knowledge through information and experiences will certainly help you with the hows of your profession, but only time provides the perspective to address the whys.

Research

One way to identify what is missing from your professional repertoire is by reading job listings. You are bound to be doing this if you're looking for your first job or to change your current one, but this is different. In addition to looking for postings that you're qualified for, mine the listings for jobs that you aspire to, for clues about the knowledge, skills, and experiences that the industry is looking for. Job descriptions can help you lay out a plan for your research that is based on how to prepare for the job you desire.

When it comes to creative research, never settle for the superficial. Go deep. Get to the source. Explore the provenance of ideas. A quick search online may provide you with some clues but it's so important to seek out experts and visit museums and libraries to see objects up close or read books that are no longer in print. There is so much in the physical world that can't be appreciated and understood on a digital device in the same way as engaging with it in person.

Remember that research can be explored on many levels. There is no getting around the need for accuracy with the facts but that does not rule out the importance of a little fiction, so long as you know what it is. Anecdotal research may include your own experiences and observations, personal accounts by witnesses to events, as well as the myths and legends that have formed around people, places, or things over time. Whether the facts around these narratives have been tainted by perspective, embellished over time, or completely fabricated they help paint a bigger, more nuanced picture.

Gathering opinions about your subject can also be a valuable approach. There are usually at least two sides to every opinion. Objectivity is important but a level of empathy that allows you to appreciate varying points of view could open up new avenues of inquiry and provide you with greater insights.

Resources
Connecting with people around shared professional interests is a limitless resource because each situation and specific collection of minds will bear fruit unique to that particular mix. Attend conferences, serve on committees, and join professional associations to access like-minds and thought leaders. Engage in conversation and contribute to the process. Less outgoing personalities should make an effort to connect with the group experience, but they can still benefit greatly from being in heightened-observation mode. Takeaways include exposure to new tools, technologies, systems, and processes, as well as training, and best practices.

Another valuable source of development is simply being in different physical places. While the value of travel can never be emphasized enough, local destinations can provide a strategic change of scenery when hopping on the next plane to an exotic locale is not an option. Keep in mind that no matter where you go to get away from things or see things differently, you'll be there. That means that you'll have to challenge yourself in ways that will feed your creative core. Go beyond polished tourist experiences and allow yourself an honest, first-hand impression of a place. Take in the unfamiliar sights, sounds, smells, the tastes, and textures of a place. Be aware of your daily routines and substitute part or all of them for new ones. Be a witness to how you feel in a place on any given day, in any weather, during all exchanges.

A professional will always be in need of reliable sources that deliver good intel. What are the sources that you can count on? Identify the print and digital information channels that supply you with the best content. Educators, authors, public speakers, industry experts, and other thought leaders are also important assets. In the end, if you've consistently collected content, your go-to resource will become your own customized reference library.

How often should a designer assume the role of a detective or archaeologist? Research can be a full-time job, so you need to figure out how much time you want to dedicate to it, and how often you're going to return to the process. Consistency is also a factor. Too much slack in between times devoted to investigating interesting subjects could slow the flow of fresh new ideas.

collected

objectivity

Perpetual Student

Learning Styles

Staying smart means staying engaged with learning of all kinds. A lifelong learner remains competitive and employable. The course you chart beyond traditional academic qualifications will depend greatly on which styles of learning suit you. How you learn is as important as what you learn. Who you involve in the process is also a factor, so you should ask yourself if you prefer being a solitary learner or do you thrive in socialized learning environments?

Systematic: Some designers employ logic and critical thinking to learn something new. Objective reasoning helps them spot connections or detect inconsistencies, and can lead to well-developed language skills that allow them to present persuasive arguments for the importance and relevance of their ideas. Equally, this kind of person may pick up practical skills by rationally figuring out how to do something before they've ever even attempted it.

Hands-on: When it comes to making things there will come a time when learning by doing is the ultimate test of your comprehension, and practice the only measure of your mastery. There is no substitute for hands-on experience because it builds muscle memory and hones your ability to anticipate the kind of challenges that you will encounter in real-world situations.

Information: When it comes to absorbing information, people usually favor one delivery system over others. What inputs best help you process what you're learning? Reading a text? Listening to a lecture? Or watching a video or a live demonstration? Even if your preferred method is not the primary source, remember that you can supplement your experience with any of the others to help lock down the knowledge you are looking to acquire.

Institutional Education

If your professional development includes putting yourself back into a traditional school environment, you may be asking yourself if this isn't taking a step back rather than forward. Does admitting that you have more to learn diminish your professional status? The answer to that one is no. Is there a fear about fitting in? There may also be some fundamental concerns about whether you have the time, money, and support system you will need to accomplish your goals.

Once you've passed that gauntlet, some more personal assessments will be needed. Taking stock of your strengths and weaknesses will help you make smart decisions about the kind of environment you need. Are you organized? Are you being honest about the skills and level of mastery you currently possess? Are you ready to explore new subjects as a novice again? Are you committed to finishing?

Deciding on the right school will mean finding a good fit. Although many schools may offer similar programs, each institution has its own philosophy, and its own personality. After asking about the scope of the curriculum, class size, homework load, alumni, faculty, and facilities, some research into the school's online presence and reputation in the industry will round out the picture. Accreditation is a concern if an advanced degree is one of your goals.

Remember that you bring something into every classroom situation. Work and life experiences provide a returning student with a greater level of maturity, determination, curiosity, and a unique perspective. One of the compensations of any learning challenges associated with an adult learner is that the depth of any kind of learning increases as you get older.

Alternative Disciplines

Hobbies & competition: Pursuing other hobbies can yield many benefits, not least of which are transferable skills. The science of cooking and baking, for example, is an art form that requires precision but also allows for interpretation and improvisation. Adding the element of competition raises the stakes by adding stressful situations and the need for speed.

Frontline education: There is no better way to learn about the consumer and how your product stands up to public scrutiny than working in retail. Working on the frontlines is an education like no other. Real-time dressing room feedback, alteration needs, and the reasoning behind returns are just a few of the invaluable pieces of information that a designer can take back into the design process.

Costume design: Costume design challenges a designer to use their skill set in a different way. Instead of designing for the consumer, they must apply their craft to building characters and telling stories. It also requires that a designer consider the type of performance and how costumes will factor into the bigger picture—sets, lighting, and storyline.

Conservation: Conservation work opens a doorway to the past. Whether it's working with museums, collectors, or vintage shops, access to historical garments exposes a designer to world of old techniques that may be new to them. It also challenges and expands their grasp of fashion history.

Teaching: Teaching provides a design professional the opportunity to pay it forward and continue to learn about their craft. Students will often challenge your views, offer unconventional solutions, and thought-provoking insights based on both their inexperience and their unique perspective as the next generation.

Deliberate Learning

DIY Curriculums

Designing an educational process for self-teaching requires some planning—a process which in and of itself can be instructive. A good curriculum lays out a vision for your personal program, and should be based around specific questions you want to answer or skills you want to master. It will set a tone for your learning experience and relates it to a timeline so you should be able to envisage a definite progression and reflect on it along the way.

When you've identified areas you want to learn about or improve on, break them down into manageable units. Design a syllabus for each unit that defines the scope of each specific subject with goals and objectives; identify the materials or resources required to help you; and set yourself assignments and assessments along the way.

When you are self-directed you have the freedom to delve deeply into the development of your expertise in one area while also moving beyond the boundaries of that subject to introduce yourself to and examine the fundamentals of many others—a combination that will provide you with the tools to carve out exactly what you want from your professional development.

Customized educational frameworks for the fashion design professional may include any combination of courses that introduce skills sets or improve upon them, for example:
- Creative problem-solving
- The engineering and construction of objects
- Strategic thinking
- The cultivation of business acumen
- The development of technological expertise.

Independent Education

Traditional systems built around grades and degrees, diplomas, and certificates may have provided you with the credentials to start your career but they need not be the right framework for your continued learning. What you can do with your knowledge is more important than the documents that prove you've gained it. Declare your independence and set your own terms. One of the great advantages of an autonomous education is that you determine what serves your personal growth, professional goals, and is worthy of your time and money. A measure of humility is at the heart of that determination because you must always take into consideration that you don't always know what you don't know.

The landscape of independent learning has no boundaries. Resources are everywhere. Online courses provide content with a measure of structure and interaction. Video tutorials offer what you need to know on demand. Conferences and special events provide access to world-class thinkers and like-minds. They also generate talks, panel discussions, and interviews which become available online as videos or podcasts if you can't be there in person. Travel opens doors to culture, adding depth to your personal development as a learner. Optimize each resource by finding a method of engagement that best suits you.

Recent graduates and professionals may return to education with a lot of baggage that narrows the scope of opportunities available to them. Adopting a beginner's mindset goes a long way toward approaching new material with an open mind, free of prejudices, and full of enthusiasm. It makes it easier to learn a step at a time, to deal with setbacks, to embrace not knowing, to manage your expectations, to be more concerned with the right questions versus magic-bullet answers, and to be in the moment, getting the most out of every opportunity to learn.

"In the beginner's mind there are many possibilities, in the expert's mind there are few."
Shunryu Suzuki

Self-Discipline

A lifestyle of professional development is a noble pursuit, but the best of intentions can be undermined by a lack of self-discipline. In situations without the structure of a classroom and the benefit of time with an instructor or peers, willpower becomes your most valuable asset. This doesn't come easily for most, especially those in creative fields like fashion who often see discipline as suppressing their creativity rather than safeguarding its development. This is why designers must set themselves up for success with a well-defined plan that addresses both short-term and long-term goals.

Meeting any challenge requires solid commitments. You will need to block off the necessary amount of time to organize and execute the work, break the work down into measurable steps, prioritize and manage the sequence of steps in the process, and secure access to an environment conducive to learning. Success ultimately depends on having motivations that are able to stand the tests of acknowledging weakness, facing possible failure, and processing disappointing outcomes.

This level of clarity and commitment will help you deal with naysayers, distractions, and anything that prevents you from getting to work. It will also help you work through the boredom and frustration of periods when things don't seem to be moving fast enough. Downtime, slowdowns, and breakdowns are all natural parts of the ebb and flow of any pursuit.

In the end, feeling a sense of ownership over your own your work can be just the motivation required to persist and finish what you start, with no excuses. Whoever you answer to for the work that you do you're ultimately accountable to yourself first and foremost. The last thing you want is to end up with many unfinished projects.

history

Your Fashion Inheritance

History

While history is a part of most fashion curriculums, it can often be reduced to light surveys that focus on memorizing dates and descriptions. This may tick the academic box but does a great disservice to students who are usually already undervaluing the impact of this resource. In the interest of expediency, more and more schools are failing to allocate the amount of time that is necessary to develop a productive relationship with the past. That is why every designer would benefit from cultivating that connection and finding relevant, practical applications for the reserves in this vast bank of knowledge—whether it be at school, on the job, or out in the industry.

There will be periods in history for which we will have a natural affinity. We may find ourselves attracted to the costumes of ancient times, foreign lands, or alien cultures because they break so distinctly with our contemporary approaches to clothing design. On the other hand, our tastes could be more closely aligned with modern fashion eras that produced designers facing challenges that we can relate to.

We are inclined to be sentimental and idealistic about the points in history that we favor, foregoing the exploration of others. Here is where it is important to remember that every fashion designer inherits all of history. While we may not use every word in the dictionary, having a large, comprehensive vocabulary to pull from is a huge advantage.

"A lot of people believe that you don't need to know the history and that creates newness. I disagree: we should always be informed and then destroy it."
Louise Wilson

66

When reminiscing about more recent fashion history, there may be an inclination to reject its value because not enough time has passed. If we use Laver's Law as a guide, fashions become dowdy within a year, hideous within 10, ridiculous after 20 and only after 30 years do they begin to increase their value as amusing, quaint (50 years), charming (70 years), romantic (100 years) and beautiful (150 years). Padded shoulders and pencil skirts were essentials of 1940's fashion but their influence waned for 40 years until 1980s power dressing brought them back into favor. The popularity of that silhouette has since fallen into decline once again, but if Laver's Law holds true there is a pair of statement shoulder pads in your near future.

Legacies

Within the larger frame of fashion history, there are smaller, more personal pockets of the past that can be used to round out a body of knowledge and mature as a designer. When a designer delves into their own ancestry they begin to build a bridge to past generations and learn how their lineage fits into the bigger historical picture. Between the foreign and the familiar a designer can begin to augment the definition of who they are.

Examining the past can lead to the discovery of connections to other countries and with them new cultures and customs. Cultural identity begins to evolve and designers contribute to a collective memory through the work they create. Being on that global stage reinforces their position as citizens of the world, something that enriches what they produce.

Regional sectors of the fashion industry also provide a unique heritage that can be tapped into. Designers are part of local fashion microcosms whether they

work in a major cities or small towns. Learning about and from the designers, manufacturers, retailers, socialites, celebrities, and collectors who share your geography may yield a valuable education and establish an authentic sense of community.

The varied histories of fashion houses are also part of our collective heritage. The origins and development of fashion brands are worthy of study. There are those that command respect because they have evolved and stood the test of time. Others can be admired for creative contributions, innovations that transformed the industry, or because what they did, and when they did it, defined a generation.

Body of Work
Specialize in someone, and focus on their body of work. As a study subject, well-known designers have a lot to offer, but often so do the more obscure talents that never became household names. Become well versed in how they approached and solved design challenges, or responded to the fashion needs and desires of their clientele. Even personal lives can be a source of inspiration or serve as warnings of what not to do. Allow yourself to "think in the style of" and ask yourself, what would they do? In the end it's just supposition, but indulging in exercises of creative empathy based on a particular body of work will often provide unexpected insights.

Developing as a fashion professional also means finding common ground with peers and the public. Learning about what have come to be regarded as classics is really the study of reference points. Garments, accessories, and styles that are considered timeless provide us with a link to our shared legacy and each other. Iconic figures in fashion and popular culture also become touchstones in communicating

fashion. A designer who moves beyond the broad-strokes definition of a classic is able to better understand the power of the garment or its creator's influence and interpret it effectively through their own work.

Although the fashion industry's archive of one-hit wonders might look like a catalog of dated material, a designer should not be rejected out of hand. For better or worse the nature of the industry is based at least in part on the disposability of ideas. In the pursuit of the next novelty these short-lived spikes in the fashion timeline are a treasure trove of oddities.

When it comes to researching any designer's work—past or present—the issue of intellectual property should always be considered. A designer who can learn from another's work has no need to duplicate it. They are able to connect with an idea and still protect it.

Framing Forecasts

Forecasting
The first step in talking about forecasting is to demystify it. It seems like one of the most glamorous and exciting of fashion professions and it's easy to be fascinated by the mysterious quality of predicting the next big thing. In fact, any attempt to forecast trends in the market comes down to making an educated guess. The more educated the guess, the better the odds of getting it right. A great deal of work goes into collecting and analyzing the information that helps a designer to predict change and put their business in a position to save time and money.

To succeed in forecasting you must become a keen observer of everything in, around, and outside your sector of the industry. You will need to collect extensive data about what products your target customers are buying and ask how color, shape, design, and themes are influencing your decisions. How do customers' experiences of special events, popular culture, and social movements drive their desires? What impact does the traditional media and social networking have on your customers' spending habits?

After gathering and analyzing the resulting intelligence it becomes about links and leaps. Recognizing patterns and connecting the dots between what is of interest to you creatively and what is happening in fashion, art, and design, as well as technology, politics, and the economy, is what leads to the perception of trends. In spite of the fact that digital technology has become a great leveler, geography remains an important indicator because of location-specific cultures that influence trends. With that information in hand, a designer can begin to speculate, frame their ideas, and package them for consideration.

"With my eyes turned to the past, I walk backwards into the future."
Yohji Yamamoto

The last line of defense before committing to the adoption of a possible new trend is consensus. Whether it takes shape as an internal matter or it becomes something that is explored further within the industry, a designer needs to decide whether or not it is viable from a business point of view. The trend must also be in line with their brand because one size does not fit all. Finding your sweet spot is a very individual thing.

Trends

Trends break down into two fundamental groups. Macro-trends, which are long-term drivers, may have an arc of several years, making them a directional investment. Micro-trends represent a more immediate response to the market and often have a much shorter lifespan. While a micro-trend might be classified as a fad, its temporary nature may actually be a reflection of how fashion seasons are being broken down into smaller and smaller micro-cycles.

When a designer sets the right pace for their business they are in a position to make better decisions about when and if trends will play a part in their process. The designer who wants to be the first to market and appeal to early adopters must make an investment in staying ahead of the curve. That investment can be costly and is a gamble that may yield profits and critical acclaim—or not.

Fast production turnaround times permit designers a more judicious approach to trends. Designers who wait and see can be first to follow, if not first to market. This may not place them at the forefront of fashion but does provide a safer bet, and allows them to still be a part of the conversation. Traditionally, larger companies that mass-produce have been in the best position to take advantage of this strategy, but advances in technology have made it possible for smaller outfits to take the same approach.

predicting

Designers who pride themselves in pushing back against the industry may choose to ignore trends altogether. That used to mean severely limiting their reach, but this is no longer the case. Digital communications have the potential to expand their customer base on a global scale. Rebellious designers also appeal to a counterculture consumer who is looking for ways to stand apart from the norm. And, somewhere down the line, these maverick designers could turn out to be ahead of their time and end up initiating future trends.

Interpretation

Forecasting is a filter that is always open to interpretation. A designer's predisposition regarding novelty and disposability are examples of personal filters that can be applied to the interpretation of forecast information. The scope, scale, and reach of a potential trend are yet more considerations when making the decision to adopt, drop, or postpone the use of information.

Once products are in play the interpreters get to work putting trends into motion. Buyers translate for the retail floor. The media decides what deserves to live on the pages of a publication, and stylists choose what they feel is worthy of their clients. Every purchase represents a vote cast by a consumer; how the consumer actually wears it adds another dimension to a trend and can further influence the trend-watchers. If the essence of the trend and the designer's intentions survive that gauntlet, then a victory can be declared.

Not all trends are new. Ideas without expiration dates can be repackaged for a new audience. The easiest way to do that is to find a fresh perspective on it and build new language around it that speaks to current attitudes on everything from gender to the environment.

ASK FOR HELP

FOUR

Ask for Help

Learning from experienced professionals is a tremendous advantage for those who avail themselves of it. Asking for help requires that you acknowledge your need as well as their value, and that you are clear about the boundaries of the relationship you are looking to build. Figuring out who, and how to reach out to them, requires more than just working up the courage to make the ask. A little research and planning go a long way to gaining the respect of those who you wish to learn from. Take the time to research, collect and consider your thoughts, craft your questions, and select the time, place, and manner in which you will make your initial contact. Putting the time and effort into figuring out the specifics of what you're looking for brings you one step closer to establishing a successful relationship.

time

looking

"As the fashion carousel spins ever faster, the concern is that, while the stream of newness never runs out, there's going to be a good deal more crash and burn among designers in the future."

Suzy Menkes

Mentorship

Knowledge & Experience

Mentors are important. So much so, that many corporate environments implement mentorship programs that allow those just beginning their careers to learn from seasoned executives. Sadly, not all companies have the resources to set up and manage these kinds of programs and individuals may have limited access to leaders in their field. If you're going to make the effort to reach out for guidance you will need to do more than find where your professional and creative interests align.

One cautionary note about looking for a mentor: Success in the fashion industry is not always the result of a meritocracy. Not everyone at the top has studied their craft or put in their dues. Beyond what you can find out about them on their website or in the media, take some time to learn if they are respected within the industry and, more importantly, by those who work under them. Character and commitment correlate with wisdom and experience.

Although a mentor may end up playing a very influential role in your professional development, not every mentor is in a position to alter the course of your career, or choose to do so even if they are. You might want to assess whether or not they have the kind of influence that can get you an interview. Do they have the power to hire you? While these should not be reasons to seek out a mentor they are practical considerations in the business world.

A mentor may look good on paper but compatibility plays a major part in making the mentor-mentee relationship a positive one for everyone involved. While this professional will be sizing you up based on what you bring to the table you need to be measuring the mentor up as well. Do they have an earnest interest in mentoring you? Do they have the time to

"Colleagues are a wonderful thing—but mentors, that's where the real work gets done."
Junot Díaz

meet and check in with you on a regular basis? Is their communication style and their temperament a help or a hindrance?

Wisdom

First and foremost a mentor is a role model. Woven into the history of their successes and failures is a wealth of knowledge and experience tempered by time. This formula often results in an increased capacity for making sound judgments, as well as the desire to reach back and help those coming up. Careful examination of their path to success may reveal clues about how to make your own smart choices and find meaningful motivation.

While respect should always be extended to the person and their accomplishments, it should not be confused for trust. Trust is not a default in the mentor-mentee relationship. It must be earned. Being in a position of authority—perceived or actual—a mentor's feedback carries a powerful punch. When serving as a sounding board, any enthusiasm or approval by the mentor may be interpreted as permission. Any question of the mentee's readiness, on the other hand, can be taken as a rejection. Mentors do bear the responsibility for how they express themselves, but mentees need to be sure that they are not especially sensitive or giving all their power away.

In addition to how a mentor might influence a designer professionally, they model behavior, life skills, and strategies that provide insights into creating a well-rounded life. And because a mentor is only human they might just as easily serve as an example of what not to do in particular aspects of their personal and professional lives.

Internships & Volunteer Opportunities

Good internships that allow you to work directly with people you respect and admire are not easy to come by. Paid internships are even harder to secure. There are practical, ethical, and legal issues to consider when it comes to unpaid work, and working for a pittance or for nothing when you're struggling to pay the bills can be stressful, which is why taking advantage of internships while you're in school is a good idea. You must also assess whether or not an unpaid internship will provide you with what you want to get out of it and not just be a matter of providing free labor. If you have the promise of training, mentorship, or a pathway to a job it can be a worthwhile investment.

If there isn't an internship to be had, an interview is a way of learning more, and can serve as the basis of future relationships. Interviews can be framed within the context of research for a project, a blog post, or any situation in which there is a clear purpose for the information you gather, besides your own edification.

Getting the best out of any volunteer situation has little to do with the actual responsibilities you'll be given, and everything to do with the intent behind your decision to volunteer. By treating each volunteer opportunity as a combination of a case study, skills-assessment test, and network-building exercise, you will walk away with so much more than if you just show up and go through the paces. While you should be getting something out of any volunteer position, also be certain that you have added something of value to what you have participated in. Your attitude and commitment to excellence in any task assigned to you allows you to own that experience and means the experience becomes more than another notch on your resume. While it may not always be obvious or immediately acknowledged, the quality of your contribution will become a part of the way you are defined as a professional by others.

Protégé

An Eager Mind

Fashion, like many other craft-driven trades, has a long history of master couturiers supervising on-the-job training for the next generation of new designers. Traditionally, apprenticing with a master in their field was a privilege and carried a great deal of prestige. Today, short-term internships have replaced more rigorous long-term commitments under someone else's wing.

"Protégé" is another word for apprentice. Both words have fallen out of favor among aspiring designers because many of the educational programs they come through are in the business of producing fashion "stars" rather than designers who are interested in being highly skilled artisans and technicians above all things. The mindset and the motivation behind each approach are completely different. Those looking to keep pace with the industry and society may not see the value of three, five, seven, or ten years of apprenticeship—in addition to their academic training—before considering themselves ready to assume the mantle of fashion designer.

The mind of a fully engaged protégé is keen to learn. Their curiosity is constant. No skill is undeserving of the time it takes to master. A sincere deference to an expert's methods is important because it is built on the benefit of their experience. No one should place themselves in a position in which they are being taken advantage of, but a healthy amount of humility will serve you well. There is great dignity and power in learning through service.

Becoming proficient in anything always takes a substantial amount of practice—so you'll need to have enough self-discipline to put in the hours, or make gaining that self-discipline your priority. Practice practicing: this investment will help you intensify your focus, adjust your speed to each situation, break down any goals into manageable components, record and reflect on the process, deliberately execute repetitive tasks and manage the boredom associated with them, move beyond personal safe zones and push to make your work more challenging, learn when not to force something so that you can explore alternative solutions, seek out feedback, measure your progress, and celebrate your accomplishments.

Moving On

There comes a time when the shift from protégé to professional must take place. It may have been predetermined on a mutually agreed upon timeline or be initiated by either party, but there should be some way to mark the occasion so that the transition can be processed mentally and emotionally. It may take the form of a promotion within the same company, but leaving the nest is a more likely scenario.

The first time a designer is given license to spread their wings can be as exciting as it is unnerving. Instead of graduating from the master-apprentice relationship with grace there may be an urge to push back, assert oneself, and defy the person who has set the rules for so long. It's a natural instinct, but resist it if you can. Instead, choose to remember and respect the history you've shared.

grace

When the dynamic of the relationship changes in this way it is time for both parties to begin redefining their roles. If you feel you have benefited from the experience you may seek out positions that allow you pay it forward and pass on what you've learned to the next generation. It could also be a changing of the guard—in other words, a time when you find yourself in new circumstances and in need of a different kind of direction from a new source.

Continue to share your accomplishments with those who have been instrumental in your development. Making the effort to keep the lines of communication open serves several purposes. In the short-term it's fun to focus on the positive, and during hard times, comfort and encouragement can be found in people who know you well. In the long-term a time may come when you are looking for guidance at a different juncture in your career.

Entry-Level Experience

In lieu of an official apprenticeship, an entry-level position—or series of them—serves a similar purpose because it is rare that recent graduates step directly into the role of designer, or have enough cachet to attract an investment of the support and resources they would need to launch a full-scale business of their own. Either path helps lay the foundation for your entry into a higher level of the professional workforce. The phase that follows school and a period of apprenticeship is that of the journeyman.

purpose

At this point mastery becomes more than a matter of education and practice. The fashion journeyman can count on that strong foundation, pull back the blinders that kept them so focused during periods of training, and open themselves up to the unexpected. Like an experienced musician who knows how to play the book backward and forward is also able to improvise and springboard off cues from other musicians, a seasoned fashion designer can tap into their well-informed instincts to take advantage of opportunities that arise when seemingly random people and ideas intersect.

Once a designer begins to hone those instincts, and learns to trust and act on them, the trajectory of their career may offer them possibilities that they had never considered before. The designer is building their résumé and reputation with every choice. Their particular mix of skills and qualities, together with some fortunate timing, helps build the momentum of their career.

This also expands a designer's professional network. Instead of collecting business cards, they are collecting shared experiences within the industry. References, recommendations, and general word of mouth carry more weight because they are founded in authentic relationships.

network

Scholars

Comprehension

Someone who has dedicated their professional life to research is more than a living library of information. A scholar should be able to help with specific inquiries, but beyond this, scholars can provide a wealth of experience for all things connected with learning. Adopting scholarly methods can help you move beyond general knowledge, increasing your awareness and depth of understanding.

Historians may start their study of the past with a book, a document, or an artifact that provides clues to the direction their research should follow. Each new connection to the past helps them put the puzzle together. With enough physical and anecdotal evidence they can analyze, interpret, and invite critiqu, to begin establishing context for the subject of their study.

Scholars who employ scientific methods start with a theory that they believe can stand up to rational inquiry and reasoning. They will observe, test their observation through experiments that can be recreated, challenge results, and measure them against rigid constraints and controls before making conclusions as to whether or not their theory is supported by the facts. The scientific mind is also fully aware and open to the fact that data yet to be revealed could alter, refine, expand, or completely disprove their results in the future. This systematic practice is becoming more important to the designer as science and technology become more fully integrated into the design process.

Experiential study produces theories that are likely, if not necessarily definitive. First-hand experience and observation via the senses play a part in examining any assumptions the scholar has set out to prove. In spite of it being a subjective approach, it provides

insights into fluid subjects like society and social relationships. The inferences that can be made inform the development of a theory or philosophy that guides a designer's approach to design challenges.

Specialization
A narrow subset of the scholar set is the specialist. They concentrate their attention to the advanced study of a particular branch of fashion. Engaging these authorities usually becomes an invitation to go down the rabbit hole together. Their aptitude for magnifying the minutiae reveals a whole new world of information. Granted, these micro-units of analysis won't register with everyone butthey serve as yet another avenue of exploration of the field.

The precision and specificity of this kind of research helps to clarify a designer's objective. Acute attention to detail sharpens their focus. Full immersion in a micro-environment trains them to recognize minute patterns and discern between even the most subtle of nuances.

One of the primary purposes of specialization is closely related to jobs that require extensive knowledge of the origins of objects and information and the ability to authenticate them. A particular advantage for a designer-specialist is how it may position them as a valued asset when creative teams are being put together.

Keeping Current
Scholarship need not just be about the things that have come before. Keeping up with current events, new practices, and innovative techniques also merits immersive study. Staying informed allows a student of fashion to make correlations between the past and present, putting them in a better position to make decisions about what is relevant and what is worthy of further exploration or adoption.

interpretation

Direct access to the original sources of prevailing opinions and industry breakthroughs is more tangible than excursions into the past because you are dealing with living, breathing individuals. Who are the thought leaders in your field? How do you engage them? In the interest of transparency, most brands and personalities provide comprehensive amounts of content about the company, the individual, and the work online. Social media opens up the lines of communication, inviting discourse, knowing that the public expects a two-way conversation.

Staying up to date on the contemporary also entails being informed about both sides of a subject. Limiting your sources to ones that reaffirm what you already like or know is a waste of time in the quest for knowledge. Breaking out of philosophical, cultural, and political bubbles makes for a more balanced interpretation of the pros and cons of any situation. Designers who allow themselves to be challenged by opposing viewpoints are just as apt to have their beliefs validated as be motivated to modify their position when circumstances call for change.

Reliable resources are essential so that you don't get carried away with half-baked concepts reported as news, misleading ideas from pseudo-experts and self-appointed voices of authority, and fame-based fame. A designer must thoroughly examine their source as well as the subject. Find consensus among peers in the industry to carefully curate your sources of information. Fact-check and then double-check. Establish your own criteria for what constitutes an expert. It's not just about misinformation but about the waste of time when your attention is diverted from credible content.

Coaches

Assessments

Big companies often bring in consultants to observe specific aspects of their operation and assess how they can improve their performance. Coaches provide a similar service to individual professionals. They use assessment tools to establish how well positioned you are to accomplish your goals. Coaches are not in the business of teaching you what to do. Instead they put you on a path of self-discovery, hoping to get you to develop your own strategies and generate your own solutions, cheering and challenging you along the way.

A coach's plan is always action-based. Specific, measurable objectives must be planned. Someone being coached is expected to face hard truths and answer tough questions designed to build their self-awareness. Their deep-rooted attitudes and beliefs will be challenged. The process is built to break bad habits and behaviors.

Setting and meeting a series of deadlines assigned for each step in the process contributes to a sense of accomplishment and gives the coachee a stable foundation to build on. A coach will guide and advise throughout, but in the end the designer will walk away with the highly transferable skill of self-management.

Once goals have been met the designer and the coach can review the experience and the results to determine whether or not there is more to be done on the same front. At that point it may be time to set new goals with the same coach or consider moving on to one with a different specialization.

"Everyone needs a coach. It doesn't matter whether you're a basketball player, a tennis player, a gymnast or a bridge player."
Bill Gates

Defining Goals

The best way to manage change and challenges is to work closely with your coach to set clear goals. The more specific the parameters the more targeted the feedback can be. Vague goals will produce vague results. Breaking down and clearly defining your objectives will make their execution less daunting.

Coaches can help you identify goals that reveal personal strengths and abilities, as well as weak areas like too much or too little self-confidence, lack of empathy, and weaknesses in your relationship-building strategies, so that you get well-rounded guidance. Adjusting attitudes and replacing defeatist language like "I can't do this" with positive alternatives is another common concern.

Group dynamics can make or break a project. When companies bring in a coach to serve the entire team this can facilitate excellent teamwork and improve overall performance. In addition to being an investment in the task at hand, this method of coaching influences the future of a team and the long-term productivity of a company.

There are some common goals associated with advancement that most professionals will benefit from. Managing workloads, delegating effectively, budgeting money and resources, handling stress, making impactful presentations, and understanding complex relationships are a few of the skills a coach can introduce or help develop on the job. Maintaining a healthy work-life balance or refocusing a career path are also major goals that can be addressed through coaching.

If you don't have access to coaching support there are some fundamental coaching tactics that you can adopt as part of your fashion design practice:

- Self-assess regularly.
- Define clear goals and objectives.
- Record and review your progress.
- Commit to the process and make the time.
- Get organized and be prepared.
- Make use of all your resources.
- Challenge your own assumptions.
- Be in your own corner.
- Plan your offense as well as your defense.
- Know when to shift into neutral.
- Be accountable for the results.
- Reflect on and reward successes.

Taking Action
A coaching experience involves taking action, often in the form of practical exercises that can be performed in the workplace. However, to fully and realistically integrate all that you have learned about yourself will require both long- and short-term timetables designed to keep the knowledge you've acquired in play once the process has ended.

Getting these good practices into the day-to-day activities of your job requires action be taken in steady increments—regluar daily and weekly applications of your new expertise or mindset. Each recognizable increase in the degree of a competency or minor alteration to your behavior becomes a self-reinforcing reward. More substantial activities, like the development and execution of a complete project, necessitate longer incubation periods—perhaps monthly pockets of time that test your commitment to the insights coaching has provided.

Once a designer is able to start to schedule in terms of years, the elements that they've adopted from coaching sessions will likely have become second nature. At this point will no longer be managing a calendar of activities; they are navigating their career.

Advocates

Champions

Among the many different types of supporters a designer may reach out to for assistance, a patron is one of the most lucrative. Finding those who see the value of your work enough to invest their money and parlay their influence can also be as rare and elusive as unicorns. Few designers find themselves in a position to court a patron, but they can strive for the kind of excellence and visibility that would attract one.

Proper journalists make an effort not to play favorites, but it's not rare to see designers build relationships with members of the press that are based on mutual respect for the boundaries of their professions. The blogger model blurs the border between editorial and advertising because the basis for their livelihood is often based on perks and sponsor advertising. Regardless of the platform it is a symbiotic relationship that in the best of circumstances benefits both sides.

A designer who has built a loyal following will find that they can rally that community with authentic appeals for the endorsement of new ideas and special projects. The consumer also remains on the frontlines of engagement in terms of sales—which is how they show their most sincere support.

The importance of personal support systems should not be taken for granted. Friends, family, and neighbors are often the first to come to champion one of their own if those connections have been fostered over time.

Wellness & Being Mindful

The physical demands of working in fashion are not always obvious but they are considerable when you think about having to keep up with the pace of the industry. Burnout is a common problem because proper self-care is one of the first casualties of a fast-paced lifestyle. The stress alone is enough reason to advocate watching what you eat, keeping hydrated, making some form of exercise part of your regime, and avoiding the temptation of anything that undermines keeping fit and healthy.

Both mental and emotional health are vital if you want to actually enjoy your work. Good health also puts you in a clear, focused state of mind that allows you to cope with whatever comes your way. It begins with the most basic things your body requires: a resilient mind depends on a good night's sleep, regular breaks, and stimulation. Laughter in particular is said to relax the body, reduce stress, and improve mood, memory, and motivation. It also interrupts negative thinking and helps you reframe less than desirable situations. Emotional health becomes a matter of sharing your feelings, staying connected with people and activities that you care about, asking for help when you need it, and accepting yourself.

Mindfulness is at the heart of a healthy spiritual life. Personal faith may play a role in its cultivation but the motivation to explore your inner world can be found in the simple desire to pause and reflect on your life as whole. The benefits of meditation include a calmer mind, increased self-awareness, a sense of gratitude, and acceptance.

All work and no downtime is another war being waged on your personal wellbeing. The maintenance of wellness includes periods of rest. In a world where we are tethered to devices, going off the grid occasionally is essential. This may all seem like

a tall order but it isn't a race to the finish line. The introduction of any of these practices puts you one step closer to a healthy lifestyle. Seek out support and set realistic expectations as you would in your professional life.

Making Change
There has been a noticeable increase in the number of designers entering the workforce who are as interested in effecting change in the world as building a successful career. This growing movement of fashion activists represents a shift in values that has the potential to revolutionize an industry that continues to commit egregious offenses against people, animals, and the globe.

The desire to change hearts and minds begins with a designer's commitment to lead by example. Making informed choices regarding how their work impacts things like working conditions, fair wages, the environment, and animal rights is one of the most credible ways to spread their message and influence their network of peers. Getting that message to scale so that it permeates the public consciousness requires a larger consensus. At this point changing minds means changing policies both within the industry and throughout society. Activities might entail campaigning and protests—behavior that is more radical than a fashion designer is usually associated with. A designer's profile can also be brandished to support charitable fundraising efforts and counteracting fashion's negative effect on body image and self-esteem.

"Designers must be increasingly sensitive to our Earth's dwindling resources. It is our responsibility."
Issey Miyake

Every opportunity that a designer can seize to act on behalf of others is a way of legitimizing a cause and redefining what professionals, businesses, the media, and consumers should be taking responsibility for.

5

5

Get Down to Business

Business is the bridge between a designer's creative process and the consumer. Whether a designer is directly responsible for performing the varied and necessary tasks associated with the operation of a business or partners with someone to run it for them, they should be acquainted with the basics of doing business—how leadership roles are defined, funds are raised, distribution channels are selected, products are positioned in the market, transactions are facilitated, and transparency is assured.

leadership

partners

"The customer is the final filter. What survives the whole process is what people wear. I'm not interested in making clothes that end up in some dusty museum."

Marc Jacobs

Leading

Leading vs. Managing

It's easy to confuse leading and managing, especially in small operations where the owner, creative director, or designer may need to execute the duties associated with both roles. As an employee, knowing the difference will inform your ability to discern between those times when the spirit of the work is meant to lead and when the situation demands that you align your priorities with those of the management.

The buzzwords associated with leaders often fall into a conceptual category—vision, confidence, imagination, abstract thinking, risk, and change. Leaders are often very articulate, they can sell ideas, and are concerned with their impact on the bigger picture. Managers are identified by more tangible descriptors that relate to measurable results—tenacity, teamwork, data-driven, self-disciplined, task-oriented.

Highly motivated people and excellent work product are equally important to the success of a business. A good leader is able to set a course that inspires others to follow. They leverage their influence to create value. And although their position might imply unchallenged power they often invite multidirectional communication that includes peers, employees, and the public.

"A leader's job is not to do the work for others, it's to help others figure out how to do it themselves, to get things done, and to succeed beyond what they thought possible."
Simon Sinek

Managers are entrusted with the implementation of a plan using their power to incentivize, calculate the value of, and deliver the work. Relying on a stricter top-down hierarchy of authority they can produce the best outcomes by breaking down big concepts into manageable projects that can be executed by a team or teams.

Performance, Not Potential

Designers in pursuit of the job—and those who have already secured a position for themselves—are better off leading with performance than potential. Initially the word will be used with good intentions, but it doesn't take long for it to become the symbol of unfulfilled promise. There are some basic qualities that carry more weight with almost any employer. Entrepreneurs also need to nurture these qualities in themselves and their team.

Working in fashion implies a creative mind. Not always true, but as a rule anyone trained in fashion design deserves the benefit of the doubt. While it's an asset to be sure, an organized mind makes the most of that creativity. A flexible and adaptive personality suggests that the individual will be able to become a part of the company culture and work well with others.

A good work ethic makes that integration even more successful. When it comes to old-fashioned hard work it's about putting in the time. Being dependable means you're on time. To be considered a self-starter or someone who shows initiative should be based on active observation—looking for opportunities to be of genuine assistance. These skills become second nature with practice.

Handling disappointments, criticisms, and insults requires a thick skin. Seasoned professionals may have time and experience to thank for it, while someone who is new to the workforce can prepare themselves for unwelcome hostilities by becoming more self-aware and finding ways to bolster their confidence. Displaying grace under pressure and positivity are professional traits that suggest you are fit for your future. Inappropriate responses will only undermine any success in other areas. Displays of anger, tears, or aggression are not only disruptive but could be signs that this is not the job for you.

Communication is key in most circumstances. The workplace is no exception when it comes to the need for face-to-face exchanges of information, emotions, thoughts, perceptions, and meaning. Proficiency across the different methods of communication—written, visual, electronic, verbal and non-verbal—helps avoid any miscommunications. Write well for every platform. Compose good images. Listen as well as you speak if you want to persuade. Learn to debate both sides of any issue. Be aware of your body language and the "resting face" phenomenon in which you might unintentionally be projecting anger, annoyance, irritation, discontent, or contempt.

Incubators

Getting into an incubator usually involves a competitive application process. A designer needs to prove their worthiness through any combination of good ideas, viable prototypes, proven track record, level of preparedness, qualified team, and recognizable talent. Accelerators provide similar support systems but for a different point in the cycle of a new business. Incubators are a safe space for startups that are taking their first steps. Accelerators help businesses that are ready for transitions or looking to get unstuck.

If an incubator is your next step then do your research. Not every incubator is a good match. Speaking with alumni is always a good way to find out. Is it run like a business or a public service? Do the facilities provide the kinds of resources, services, and access to training that suit your goals? Does an endorsement from the incubator have industry credibility? How much direct interaction do participants have with mentors?

Funding may be one of the most attractive perks of being a part of an incubator. If funding is available, how and when is money distributed? What kinds of strings are attached, if any? What about media exposure? Will funds be allocated to advertising and promotion?

Bootstrapping

One of the best ways to build assets is by bootstrapping. Whether making use of existing resources to launch a new venture stems from a desire to keep full control or there is simply no other choice, bootstrapping will provide invaluable lessons in getting the most out of any resource.

After establishing how much money you can personally raise and invest in an endeavor it becomes a matter of prioritizing where those funds will be allocated and finding every place that spending can be minimized or eliminated. Sacrifices need not be made solely in the interest of austerity. They provide opportunities to explore creative alternatives when a plan is built around the budget, rather than going in search of funds to support one. Necessity may also demand that you teach yourself to do things that you cannot afford to outsource.

This approach to raising and allotting funds is just as important to a designer who is looking for a job or starting out in the workplace. The scale might be smaller but budgeting well for living expenses, wardrobe, travel, and personal development is an essential part of building a sound foundation for personal finances. They key is vigilance.

Bootstrapping becomes a litmus test for smart choices. The company or the individual that has successfully balanced economy and innovation has built credit, credibility, and collateral, making them a good investment. Beyond generating healthy balance sheets this strategy lays out their level of commitment, resourcefulness, and passion.

Investors

Investors want to know if an idea is scalable and whether it is unique enough that it can be protected legally. They are looking to make a profit which translates into dependable dividends or selling their stake in your company at some point. You'll want to know whether an investor intends to be involved in your operation or take a hands-off approach.

There are many types of investors, each with their own reasons for investing. Banks and venture capitalists are looking for large market opportunities, which rules out most startups. If your business is at this level you should be employing a team of lawyers, accountant,s and financial advisors. Angel investors are often attracted to shiny ideas—they are just as concerned with a return on their investment as anyone else—but a personal interest in a field or the allure of being involved in building something new may also be driving their choices.

Be prepared for the ask. Do you project the image of someone who can lead? Is the idea straightforward and relatable? Does the business model you're proposing have a proven track record? Have you developed a comprehensive business model with a smart exit strategy? Don't forget that you should know as much as possible about your investor as well. Be aware that soliciting too much of an investment could result in a loss of control in the business and sometimes the rights to your own name. You may want to ask for smaller amounts from more investors.

The most important aspects of entering into an agreement are establishing good lines of communication and crafting even better contracts. Clearly define what each side is responsible for when it comes to finances—including the costs of the producing the agreement, operations, rights, and any unforeseen setbacks. Is the agreement open-ended,

or does it establish specific start- and end dates? How can either party get out of the contract or renew it? Read the fine print. Have a lawyer read it. Don't sign if you feel that you're not getting what you want.

Crowdfunding
At first glance crowdfunding feels like an easy way to raise money. Skipping the middleman and going straight to the consumer makes sense, but it also requires that you address and exceed their expectations. It begins with a clear message and a promise that invests them in what you're offering as the answer to a need or desire.

One of the biggest mistakes you can make is thinking that just putting it out there will be enough—this is just not the case. The best campaigns leverage established platforms. In other words they have a base audience to pitch to. The value of that core group lies not only in their potential as backers but in their inclination to use their social currency to spread the word and encourage support of your project.

There are indicators that introducing a campaign at the beginning of the year can improve its chances, but having it coincide with a relevant season or event is just as smart. Collaborations and cross-promotions have also proved to be effective strategies. Factoring in shipping costs, manufacturing turnaround times, and unexpected delays is vital to a successful roll-out.

Establish realistic goals, and offer multiple ways to buy into the project. Each level should have unique perks. These need to be exciting incentives and be of true value to the backer. Be sure that your perks don't cut too deeply into the bottom line. Clever and engaging video is the standard. Explain how the money will be used and have a call to action. And finally, stay in touch and deliver.

"The only place where success comes before work is in the dictionary."
Vidal Sassoon

Distribution Channels

There are many pathways to the consumer. Which channel will generate a sale? One of the most traditional is the showroom. These designer representatives make it easier for professional buyers to see the product in an environment that is conducive to making purchases for their stores. They can see multiple brands, inspect garments carefully, and determine whether or not the products are in line with the goals of the retail operation

Another well-established outlet is the mail-order catalog. Print catalogs establish a presence in the home of the consumer and are usually accompanied by e-commerce sites that streamline and speed up transactions. In addition to producing a quality product, the brand must develop the kind of imagery, descriptive copy, stats, terms and conditions that make it easy for customers to follow through on a purchase.

Social media channels like Instagram have become the latest tool in the race to the register. Posts can introduce new products and inform clients about the latest promotion or delivery. Retailers create calls to action that have a sense of urgency and fashion houses share behind-the-scenes glimpses into their world to build interest and excitement.

Experiential retail is a physical manifestation of the catalog. These stores do not stock merchandise, but they do offer the consumer direct contact with the product. Items may be stocked in a warehouse or be produced on demand. In-store and online purchasing options are available once the consumer has first-hand knowledge of and experience with the item.

Click & Mortar

The scale and the style of a shopping environment will set the stage for different strategies. How a customer shops is as important as where. Consider how you might customize your approach to each unique outlet.

E-commerce websites make it possible for both small and large operations to take advantage of a potentially global audience as long as they adhere to the things that have come to be expected from an online purchase, such as speedy and affordable shipping, and liberal return policies.

Boutiques and other small-scale brick-and-mortar businesses are owner- or buyer driven. This means they rely heavily on their reputation and word of mouth. For the designer this means smaller orders that are tailored to a very specific market. Missing the sweet spot in a boutique setting could result in deep discounts that devalue your product.

Department stores usually place larger orders for multiple locations which means a designer must be in a position to front the money required for a big production run and the demands of different markets. Success in this competitive multi-brand environment relies on brand recognition. Establishing that kind of presence could translate into a considerable advertising and promotions budget. Volume is the name of the game and a designer may be on the hook for buybacks to dispose of merchandise that doesn't move on the department stores timetable.

Designer guest appearances and trunk shows provide the designer with a way to interact directly with consumers, learn from them, and build brand awareness. They can generate custom orders and off-the-rack sales. The model lends itself to both small and large retailers providing a way to determine whether there is potential for profit.

Temporary Spaces

Pop-ups are a popular way of making the retail experience project-based. Whether it's a short lease or one night only, these sale spaces offer designers an opportunity to engage a community that it wouldn't otherwise be able to reach on their turf. Like theatrical companies who use previews to work out the kinks, a designer can use pop-up stores to test out products and strategies.

Shopping parties are very old school, but there is a reason they're still around today. When hosted by a charismatic brand ambassador in an intimate social setting, a shopping party can be a lot of fun. Brands that cater to business professionals have used similar models to make shopping convenient, by bringing products and services into the office.

Consignment isn't the most lucrative option for the designer when it comes to new products, but for those sitting on unsold stock it can be an opportunity to maintain value that is mutually beneficial to the designer and the retailer.

Limited-edition launches are about temporary opportunities. Creating objects, services, and experiences that are only available for a specific moment in time to a finite number of people is the definition of scarcity and demand. When "while supplies last" really means something, objects can be elevated to cult-like status by collectors.

Positioning

The Market

Before designers introduce themselves and their work to the marketplace, they need to define and understand it. They also need to know their competition well. Only then can they figure out whether they should build a case based on how they are better or how they are different. Will the positioning strategy focus on the features and benefits of the product or how it fits into a particular category? Does connecting with the consumer revolve around targeting a specific consumer's needs and desires or will it be about how and when a costumer will engage with the brand?

In the competition for eyes, minds, and hearts, a good reputation will help secure your position. Does your audience believe what you're telling them? So long as you and your product have a clear focus that lives up to the hype and are different enough from your competition you're on your way to building one. Be of importance to your consumer. Provide meaningful reasons that keep them engaged. Go the extra mile. Whatever strategy you choose, will your strategy hold up in the long term? Consistency in all things should be your standard operating procedure when trying to establishing a solid reputation.

budget

get

funding

Even as a newcomer, a designer who is trying to position their brand as an alternative to an established player is going to need to base their strategy on the specific facts associated with that segment of the market and have the funding required to keep pace with it. Both are key line items in the budgeting of time and money. The data needs to be comprehensive if decisions are going to be well informed. When it comes to the product, how saturated is the market in this category? Is the price point competitive? Is the budget required to introduce a product on par with what the competition is doing, and more importantly does it reflect the designer's means? Markets may also be divided by climates and cultures. A designer should always entertain the idea that their target customer may be influenced in different ways depending on where they live.

Staking a Claim

When it comes down to it, where a designer works is usually a very practical matter. What can they afford? However, perception plays as much a part in positioning as finances. How and where you set up shop will contribute to how your place in the market is defined. A designer will want to frame that definition by having a clear plan for how they will discuss where they work.

It's no secret that many new businesses start off in the home—at a kitchen table, in a basement or a garage. A struggling start-up designer must choose whether to hide or advertise their humble base of operations. Will peers, the public, and the press see the charm of the situation, or will it undercut their image, and by extension their market value?

The designer who chooses to work among others in a shared workspace is tapping into resources as well as a built-in support system. Places like these foster collaborative relationships, indicate that a brand is building momentum, and project the designer's ability to work as part of a community. Products being developed in these environments suggest that they benefit from the communal creative spirit that can be found there.

Designers in a position to strike out on their own often imply that they enjoy both critical and commercial success. For many this level of independence has become a right of passage. This is true, if only because they have managed to attract the interest and the resources needed to set themselves up as self-determined entities.

Crossing Boundaries

One way to create your own unique value proposition is to stop competing in the same arenas. Place yourself in a completely different setting to see your brand in a different light and reach an untapped audience for your work. Besides the potential for marketing and profit-making, ground in alternative markets can be fun and stimulate creativity.

Be other. Pull yourself out of the mix altogether. Swimwear for example caters to two fundamental audiences. An athletic consumer requires a swimsuit that will perform under the strains of the activity. The fashion customer is more concerned with the aesthetics of the garment because it will be judged poolside. But what about a niche market like cosplay? Could a designer dedicate a part of their practice to serving this community's swimwear needs?

Find new audiences by association. A designer can align themselves with art, craft, performance, and educational institutions that recognize the value of a well-conceived retail component. Museums, for instance, are making sure visitors are exiting through the gift shop to take advantage of the desire to leave with a souvenir of the experience. These keepsakes are becoming increasing sophisticated and definitely include apparel and accessories.

Cater to the connoisseurs. Yes, there are fewer of them, but what they lack in number they make up for in appreciation and loyal patronage. There is also the matter of a higher price tag that reflects the concentration and the skill required in cultivating a specialty.

Transactions & Transparency

Assigning Value

Pricing your product involves a pretty basic formula. The cost of sourcing and purchasing materials, and production labor, operating expenses, and how much profit per unit you want to factor in will give you the wholesale price. Some of the overhead costs will include—but are not limited to—rent, transportation, utilities, insurance, legal support, accounting services, communications, office supplies, postage, packing supplies and shipping. Expenditures also include design and management salaries. Be sure not to forget yours. Doubling the sum will get you to retail.

A designer may think they can keep prices low if they bypass the middleman. But selling directly to the consumer involves additional costs. The final ticket price will include sales operating costs, customer service, and the management of deliveries, replacements, and returns. Marketing, promotions, and advertising all figure into the equation as well.

Keystone pricing (x2) is the most common markup at retail, but other factors will influence your profit margin. Supply and demand will play a role as will comparisons between your price point and that of your competitors—just be sure it doesn't become a race to the bottom. Price segmentation is solid strategy if you can implement the system—age or affiliation based discounts, coupons, promotional codes—to offer a variety of customers different prices.

"Quality is remembered long after the price is forgotten."
Aldo Gucci

Markups based on what a designer believes the market will bear go a step further, relying on the keen observation of consumer behavior and honed instincts to determine what they would be willing to pay. Psychological pricing taps into the appeal of prices that end in odd numbers just shy of a round number ($9.99 versus $10). Multiple pricing allows a designer to bundle sets that are sold for a fixed price. Raising and reducing prices will require data, careful consideration and timing. A designer who sells in different markets may want to establish a manufacturer's suggested retail price to keep prices consistent. There is always a danger of under- or overpricing. Targets for the revenue a garment or collection should generate are helpful guides in the pricing process.

Trade shows

Trade shows are designed to generate business. But are you ready? Before committing to a show there are many things to consider. Do you already have accounts? If not, are you ready to court buyers in advance? Although some buyers may be looking for new talent the bulk of their budget will certainly be allocated to brands with a track record. If you feel like the possibility of placing orders at a trade show is in proportion to the cost, then it becomes a matter of finding the right show for you.

Is the show's target audience yours? When considering the scale of the show, larger events enjoy greater visibility but they are also more competitive and expensive than smaller regional shows. Find out what the guidelines are. Coordinate your efforts with other vendors to negotiate a good price and strategic location. Budget for travel, accommodations, expenses, shipping, installation, and insurance.

Once a designer has secured a booth they will need to take measures to ensure that buyers will be drawn to it. Social media should be a part of the communications strategy before, during, and after. The design of the space must broadcast the brand in all things—walls, flooring, fixtures, signage, audiovisuals—and be customized to the space and audience. The elements should be kept simple and portable enough to travel well. How the merchandise is displayed—folded flat, hanging, on mannequin or a live model—will help attract buyers and suggest how the product might fit into their stores.

Showmanship and incentives are as much a part of the trade show experience as anything else. How would presentations, entertainment, food, beverages, promotional items, or giveaways factor into the kind of experience you want to create? Once in the space buyers should be met by a well-trained and enthusiastic staff. They should be ready to pitch the brand, close the deal, and answer any questions about terms and turnaround. Lookbooks and line sheets that include detailed product information are valuable takeaways that reinforce the transaction. Whether an interaction ends in a lead or a sale the designer should immediately follow up and follow through on anything that was discussed.

Sharing

In order to carry less debt, manage cash flow, and make the most of materials, machines, and other valuable resources, any fashion operation should consider sharing. Needs that complement each other provide an opportunity for peer-to-peer exchanges. Surplus fabrics and other inactive inventory can be sold, rented, or exchanged for goods and services of equal value. Downtime for machines can be scheduled for use by another business that is reciprocating in cash or in kind.

technological

Necessity fuels partnerships between businesses that are interested in sharing the costs of investing in the major acquisitions of stock items or new tools. Splitting the expense of large-ticket items like advertising or technology, allows both parties to minimize the outlay of cash and reduce risk when trying out new things.

Protecting ideas is important but some benefit from being shared. The pace and volume of technological innovations that affect the fashion industry is an example of an opportunity to share knowledge. The free and open flow of information about advances and how to adopt and best integrate them is one way to share the load and build consensus. There is strength in numbers and this kind of leverage drives change.

Parts of the fashion industry have adapted to the sharing economy by allowing consumers temporary access to products for a fee—in other words, renting off the rack and the runway. This kind of collaborative consumption responds to both the need for a more sustainable fashion business model and fashion's inherent challenge to keep in step with trends.

SIX

NEGOTIATE THE INDUSTRY

6

dynamics

Negotiate the Industry

At every stage of the process a designer will encounter challenges that have less to do with the work than the people involved in creating, constructing, or consuming it. Negotiating obstacles that have the power to distract from or completely derail projects otherwise poised to succeed is an imperative. Designers will be obliged to confront issues of influence, the dangers of dealmaking, and problems associated with perception, politics, and workplace dynamics. They will be tested by complications linked to criticism, cult followings, and customer expectations. Moreover, designers will need to face the ongoing struggle to communicate clearly and avoid misperceptions by developing effective language and imagery.

"*Fashion is such an octopus. You're connected to so many people: suppliers, pattern makers, production teams, marketing teams, vendors.*"

Raf Simons

Influence & Optics

Celebrity Influencers

The fashion industry is known for making use of celebrity in all its forms. The influence of friends in high places can't be denied. One of the most obvious examples is the careful curation of a front row at a fashion show. Filling those seats with highly recognizable personalities is the visual equivalent of name-dropping—or fame by association. When celebrities show up they know that they are sharing the attention of their fanbase, so it's either a sincere desire to support or a paycheck that gets them there.

While fame may be acquired in many ways, there are those who aren't household names but exercise influence steeped in well-earned reputations and respect. Some rise to the level of kingmakers because their nod of approval has the power to alter the path a designer's career. That kind of currency has a longer shelf life than being famous for being famous.

The media variety of opinion-makers represent another power set of influencers. At their best they serve as stand-ins for the consumer, attempting to assess and interpret fashion for their audience, which also means that good journalists might not always end up in a designer's corner. However, when they are able to align the interests of a reader, a listener, or a viewer with a designer's message they contribute to the conversion of a casual observer into a customer.

The crowd rules when it comes to the cash register, and that's the measure that matters. Sometimes the high-profile influencers get it wrong. No amount of critical success will guarantee a better bottom line. Buying power is the ultimate influence on the success of a brand, which is why a designer is better served by letting their audience influence them at times, rather than trying to court uninvested influencers motivated by their own agendas.

> "In fashion, there are so many gangs, if you identify too much with one, you get caught — I would lose my freedom."
>
> Daphne Guinness

Backroom Dealing

Transparency is an important part of doing business. A great many decisions will be made behind the scenes. Back-channels aren't necessarily dubious but secrecy must not be mistaken for privacy, and strategy is no excuse for subterfuge. A system of accountability is the only thing that lessens the temptation to coordinate efforts at the expense of ethics.

Seeing and being seen is an integral part of the fashion industry. Opportunities for professionals to gather and network provide ways of getting and staying on the radar of that community. Social circles also provide relaxed and inconspicuous environments for dealmaking. This is useful and can even be fun when that sense of camaraderie is working in your favor, but there is always a danger of becoming the victim of a clique that intentionally freezes out newcomers or members they feel aren't living up to their expectations.

Word of mouth is how many designers learn about a job or will be made aware of a business opportunity before it becomes general knowledge. So having friends in the industry can be a useful thing. On the flip side, consider that designers will most probably encounter a measure of nepotism working against them at some point in their careers. At some point you may need to draw your own ethical line between the advantages of maintaining professional relationships and giving or receiving preferential treatment based on personal friendships and family ties.

The deal with deals of any kind is that even the suspicion of less-than-ethical practices will result in a backlash that can saddle a professional with a bad reputation. This kind of disgrace is usually harder to come back from than the effort it would've taken to do things with integrity.

Perception

One of the easiest ways to miss the mark in fashion is to neglect how the brand, the work, and you yourself are perceived by anyone outside the process. It's a common oversight because designers assume that what they are communicating is being understood as clearly as it appears to them. The first challenge is finding out what people are thinking. What impression does the brand make? What do outsiders to the process think is the designer's viewpoint? How do others judge the work?

Becoming aware of what others are feeling about the product and the system that produces it is not easy. It requires prompts that will elicit emotional responses. Does the shape and color of a logo stir up visceral associations? Do interviews with the designer come off in a way that inspires confidence or dissatisfaction? Is trying on a garment a transformative experience?

Communication and behavior also provide insights into the kinds of impressions that are being made. How does an outsider describe what they think and feel about the designer or the dress? Is it simply a positive review? Or is it also an enthusiastic one? Do they mention any specific details? What do they do about their interactions with the brand? Are they more inclined to make a purchase or tell a friend? Although all of these observations are by nature subjective samplings from specific groups of individuals at a certain moment in time, they have the power to influence you in a positive way. Even feedback that challenges your vision will provide you with valuable and very human insights if you are open to it.

Your Team

At some point, whether it's as an employee or an owner, a designer will be responsible for building a team. There cannot be enough emphasis placed on the importance of assembling the best team possible. Each member should ideally be the best at what they do. It's also useful for those putting together a team to tap into their own personal experiences as a member of a team. What worked? What didn't?

If it's a new hire, vetting qualifications will determine whether they're well suited to the work, but the ability to be part of a team demands more than that. In some cases deficiencies can be offset by training if the candidate is a good fit for the team. Determining factors might include how curious, insightful, engaged, and determined they are. In the event that a designer is inheriting a team, it may be beneficial to edit and reshuffle to strike the right balance moving forward.

Good work can be done when a team leader is clear about what they want and team players feel invested because they know that what they bring to the table is of value. No member of the team needs to sacrifice their identity to the whole if everyone on the team is given a level of autonomy, the tools to solve problems on their own, and the freedom to learn from each other and coordinate amongst themselves.

Low retention and burnout usually indicates a flaw in the team culture of a company. Does gossip corrode communications? Are those in positions of authority instigating rivalries in the hopes of increasing productivity? Is that kind of friction sustainable or does it threaten the long-term health of the group? These concerns are just as relevant for someone on the job because everyone needs to take responsibility for the contributions they make—good or bad—to company culture.

Reorienting Roles

The world of fashion has elevated the roles of designer and creative director to such heights that anyone in those positions provides the brand with a celebrity as well as a scapegoat. The ivory towers that used to protect creatives are no longer designed for long-term occupancy. For many, the current model of a successful career is defined by the quantity, caliber, and duration of guest appearances a designer will make at different houses.

This constant shuffle of high-profile talent keeps the media buzzing and has certainly proven lucrative for a small group of elite creatives, but it doesn't provide a realistic strategy for everyone because the hype is disproportionate to the reality of working in the industry for most designers.

Decentralizing the role of the designer does not diminish the importance of a leader with vision, and their ability to provide direction. It does, however, allow the focus to be on the work, individual contributions, and the cohesiveness of the team throughout the process. Adopting a team-focused strategy invites everyone to take responsibility for the success of a project.

Success will also depend on different types of teams. Creative teams are tasked with invention, but not every team is or needs to be dedicated to innovation. Tactical teams concentrate on developing and executing well-defined plans. Problem-solvers team up to fix things and make course corrections. Some teams are charged with learning something new so that they are able to educate others and inform the project using their new skill or knowledge.

Playing the Game to Change the Game

In spite of being an industry that introduces new products with a great sense of urgency, the business of fashion can be slow to change when it comes to how it operates. Even when it comes to issues that most would agree need to change if the industry is going to evolve, the advancement of causes like increasing diversity and minimizing environmental impact does not happen as quickly as you would expect.

The most obvious and visible method of bringing about change is activism. Fashion professionals can champion a cause by promoting its message, protesting injustices, and introducing reforms. These strategies ignite situations, raise the profile of the issue and get the conversation started.

Change-makers can also utilize political, legal, and economic channels to advocate for more stable, long-term improvements. Researching the issue, rallying support, raising funds, and maintaining communications may be less glamorous than disobedience and disruption but are of vital importance. In order to make the most of these avenues you have to learn the rules before you can bend or break them to your advantage.

One of the hardest things to face about making a difference is that significant change is a long, slow process. The fact that it will take months if not years will require patience and commitment on the part of everyone involved. In some cases you may not see the results of your efforts in your lifetime.

activism

Crafting Language & Image-Making

Vocabulary

Size does matter. A large vocabulary sets you far and above the rest when it comes to communicating your ideas. Specificity when it comes to any fashion message is what differentiates you from the competition. Every nuanced choice helps make comprehension clearer for you as well as your audience. Be banking new words every day.

The more articulate you are the more persuasive you can be. Words that stimulate the imagination, engender trust, and generate interest are powerful tools when you are engaging with investors, employers, consumers, the media, and your team through language.

Take special care not to use empty buzzwords. Words like classic, chic, sophisticated, elegant, unique, luxury, and avant-garde have become generic crutches for describing fashion. They don't mean much on their own anymore. Challenge yourself to define any and all of these clichés in specific detail, and most importantly from your perspective. What does "sophisticated" or "avant-garde" actually mean to you?

Industry jargon should be used sparingly if at all. Don't pepper your descriptions with "kind of," or "like." Own the words you choose. It either is, or it isn't. And please make an effort to eliminate the words fabulous, amazing, and awesome from your vocabulary altogether. Very few things are in fact fabulous, amazing, or awesome.

Pictures

Taking a photo is as easy is a writing a note. Sometimes good timing and a little luck will result in a great image, but that isn't something you can count on. Not every shot is fit for public consumption. That is why being able to make a good picture is of great value. Welcome any opportunities to work with or learn from a professional photographer.

The basics of composing a photograph are useful whether you're documenting behind the scenes, shooting an editorial, or capturing live action on the runway. Taking what is in the background into consideration when you're framing a photograph is as important as making sure your subject is in focus. It is also worth the effort to understand the lighting. Although you want to pay attention to color, it can be corrected or stripped completely during the editing process. Some images definitely read better in black and white.

Capturing the mood and motion of a moment in time is not an easy thing to do. Thankfully video is now as accessible as still photography. It's hard to compete with the energy of moving pictures, but video still requires a trained eye and an instinct for editing so that it doesn't become a stream of consciousness without a story to tell.

In either medium the imagery should be able to tell an interesting story, convey a meaningful message, or elicit a powerful emotion—all three if you're lucky. While illustration is less common than it once was, there are situations that lend themselves to being interpreted by an artist.

photograph

Fluency

Mastering the craft of communication and the creation of imagery also requires being fluent in the language of your audience, something that changes with every situation. In addition to being aware of slang and dialects specific to groups from different demographics, anyone communicating about fashion should take into consideration the issue of society's ever-shrinking attention span.

Whether content is heard, read, or seen, the individual responsible for delivering it needs to display a facility for the material. That requires that the message have a distinct rhythm, transitions that flow, and that it all be shared expressively and with a sense of ease.

Writers are often encouraged to show, not tell. However, in the world of fashion there is room for both strategies, and there is more than one way to "tell." Sharing what you thought, said, did, sensed, or felt allows an audience to connect with a story in a very personal way. When they feel as though they've experienced something for themselves, even second hand, it allows them to come to the same conclusions as the person telling the story—if it's told well. Alternatively, there will be cases when it will be more important to explain yourself clearly by providing detailed descriptions, thorough explanations, and precise recaps, leaving no room for interpretation.

Not every fashion designer has a facility for telling stories. This does not mean that they should not take the time to become familiar with examples of good words, good sentences, and good punctuation. Read the work of others. Read a lot. Reading exposes anyone writing fashion—or working with those who do—to different styles and structures. This is just as true for anyone using imagery to tell stories.

Everyone is a Critic

Constructive Criticism

Regardless of how it is intended, criticism can't really be constructive unless the person receiving it is open to their own limitations. But if you're able to entertain the fact that you don't know what you don't know, then critique can be a positive and practical part of the process.

Being receptive to criticism is no way a sign of weakness and should not be a cause of distress or embarrassment. In the best of circumstances a designer not only takes their ego out of the equation but also has a sincere interest and curiosity about the feedback. They are earnest about learning something from the exchange.

When relevant faults in the process or the product are identified and accompanied by specific suggestions aimed at improvement, criticism can be very motivating. It helps to have the parameters of an evaluation clearly spelled out. What type of assessment are you asking for? What kind are you getting? Is it founded in aesthetics or functionality? Is it based on theory or practice? Whether these judgments are being offered in a private or public setting is also a valid concern.

Criticism will usually help identify any blind spots you may have regarding yourself, your team, your company, your product, or the market because they offer an objective, and often well-informed, outsider's perspective. Common blind spots include the things you avoid or take for granted, confusing opinions with facts, fear of change, misreading situations, and over- or underestimating what you value, believe, or trust.

"What others think about me is none of my business."
Wayne Dyer

Destructive Feedback

Criticism is especially destructive when it gets personal. Jealousy, resentment, and revenge can fuel criticism that is mean-spirited, if not all-out cruel. Although those who trade in insults and gossip are engaging in that behavior from a position of weakness and inferiority, they still have the power to undermine your efforts if you allow it.

Careless, blunt, or uninformed critiques are just as dangerous to a designer's self-esteem. Insensitive feedback may be the result of an isolate,d thoughtless moment or be the product of a flawed personality with little or no empathy. There is room for discourse with the first. The latter will never provide a level playing field for discussion.

Unfortunately, every industry has critics who position themselves as experts for the sport of taking others down. It may be for their own personal gratification or intended as entertainment for an audience who enjoys partaking in a little schadenfreude. These duplicitous and destructive characters focus on instilling fear, humiliation, and denying access.

Surviving the negativity of naysayers lies in seeing them for what they are: bullies. If they are trying to bolster their own sense of superiority, pretending, or seeking attention, then they are not invested in your growth. When you consider the source it makes it easier to dismiss anything that isn't constructive.

dismiss

The Inner Critic

Perhaps the most powerful source of criticism comes from within. Our inner critic is the voice in our head that knows us better than anyone else ever could, so it knows exactly what buttons to push. In the role of enemy it becomes something to be ignored, dismissed, fought against, or overcome.

There are many self-defeating triggers that start off as what seem like fairly reasonable questions, but can grow into big booming voices intent on drowning everything else out. Beware of disempowering messages that call into question your value, likeability, commitment, ability, or worthiness. What about the all-consuming need to be perfect, otherwise why bother? This is not to be confused with a devotion to excellence.

If we can muster the compassion for our inner critic that it deserves, we are able to recast it as an ally. Instead of a combative relationship we can embrace its efforts to warn, discourage, doubt, and criticize as a signal that means to protect us. Accepting that every fear-filled belief, limiting assumption, or frustrating obstruction we put in our own path is a natural expression of our vulnerability allows us to turn the tables on it.

Stripping your critical inner voice of its power involves breaking the cycle. Avoiding it only makes it more powerful. The moment you're aware of the voice, take action. Distract, interrupt, shift gears, change the subject, all the while doing something that moves you forward, whether that means researching legitimate concerns or breaking through unreasonable barriers to accomplishing your objectives.

Cult Customer

Engendering Trust & Loyalty

Cult fashion brands are a lesson in customer acquisition and retention. They distinguish themselves by showing how they stand in contrast to the common enemy of fashion—the status quo. They build exclusive tribes around ideologies and mobilize influencers to spread their message. These brands make it easy for their consumers to share and show off using everything from merchandise to hashtags fostering a sense of loyalty and belonging.

Understanding your customer is the only way you will be able to deliver on two very important and seemingly opposed characteristics of the cult follower—the need to belong to a group and the desire to be recognized as an individual. Meet them on their turf. Listen to what they care about. Ask them how they like to engage with others.

"People want to be in their own fashion tribes, so they want to wear the same clothes to be connected to everyone else in that tribe. But they want to be different from other tribes."
Christian Lacroix

The other counterintuitive decision to be made is to stop behaving like the merchant. When it's not all about the sale you can expect more from the customer than the price of the product. A brand that plans, designs, and manages commercial environments built around lifestyles is able to position these spaces as hubs for those communities. Successful placemaking is also sensitive to the employee, putting quality above quantity on the job as well as at the register.

individual

Beyond Satisfaction

Exceeding expectations has come to be expected. It should be easy to be a customer. Brands that can make over-delivering a part of the culture are able to continually surprise and delight their loyal customers. These rewards come in many shapes and sizes.

The easiest way to create a generous environment is to remember that our clients are human, and so are we. Any operation that can be automated provides an opportunity to substitute technology at the cost of the personal touch. And who does not appreciate a measure of flexibility when it comes to company policies? This is easy enough when the boss is on hand but staff should also be empowered to respond to human-centric situations.

Building a history of positive experiences builds trust. Instead of random isolated moments, going the extra mile should be the rule rather than the exception. Customers should have reason to believe that anyone associated with the brand has done their best, even when things don't go according to plan.

So many interactions can be filtered through technology today that we must make conscious decisions to find ways to connect with customers face-to-face. There is no substitute for meeting your customers in person. Direct engagement allows both sides to share full sensory experiences that reinforce the relationship.

flexibility

Who Owns Your Brand?

A brand lives in the space between decisions about it and the experience of it. The team behind the brand puts strategies into play but any equity is at the mercy of the consumer's perceptions. The product or service may not be the deciding factor when it comes to making it a commercial success. So, who really owns your brand?

They do! Let them. Your customers might not own shares in your company but they do own their experience with the brand. They are able to grant or withhold their support just as easily as an investor would if the brand was not living up to its promise. With so many choices available to them the fact that they've chosen your brand should never be taken for granted. Their loyalty should be earned not expected.

That doesn't mean you don't have a stake in your own business. You made it, you own it. As an owner you make final decisions and own any intellectual property associated with the brand, but your role is more complex than that. In addition to day-to-day operations, you are accountable for the long-term welfare of the brand.

As a steward of the brand you are dedicating yourself to protecting its present, future, and historical legacy. Initially this may be a one-person job, but stewardship needs to grow to include the entire organization as well as the consumer. Putting systems in place that provide clear guidelines and establish best practices will empower others to represent the brand and protect the brand's integrity.

loyalty

SEVEN

PLAN STRATEGICALLY

compass

Plan Strategically

In order to take full advantage of resources and
be prepared for opportunities plans must be made.
With objectives in place you will want to prioritize
the steps that will get you there. The impetus for
the development of a strategy could be a creative
vision, careful reasoning, or a response to a situation.
Strategies may also emerge organically.

A brand can be used like a compass, helping to
pinpoint the direction of communications, drive the
development of collateral, and determine competitive
strategies for the marketplace. Strategic planning will
be an advantage during the decision-making process
when deciding where to produce your product, how
to map out the path of a career or a campaign, and
which platforms will best serve your objectives. It
will also help in the creation of realistic timetables
and provide insights into how and when to change
course when the need arises.

impetus

"There's only one very good life and that's the life you know you want and you make it yourself."

Diana Vreeland

Brand Compass

Brand Identity

Companies aren't really people, but in the way that the law recognizes corporations as independent entities with rights, responsibilities, and liabilities, the consumer relates to a brand in much the same way. Brands become stand-ins for cultural archetypes.

Does your brand bring magic into people's lives? Or does it assume the role of caregiver, hero, or romantic? Is it actively exploring new frontiers or revolutionizing industries? Is it built on simple pleasures, playfulness, or the creative process? Does it embody authority, wisdom, or the everyman?

While archetypes do help establish common ground and a shared language, they don't have to be reduced to stereotypes. They become more complex and interesting when you imbue them with personality traits and assign them physical characteristics. Personality comes through the tone of marketing and how sales staff is trained to interact with customers. The physicality of a brand can be felt at every touchpoint—the product, packaging, and space.

Once all these things are in play the essence of the brand becomes evident. Communicating the brand becomes effortless because it speaks for itself. The values, vision, mission, and promise of the brand are all put into context.

archetypes

True North

A designer's philosophy is at the core of their identity, the way they see the world, and how they they respond to their environment whether it is creative or commercial, natural or synthetic, political or cultural, functional or complete fantasy.

Philosophical reflection will help designers answer personal questions and concerns about their work. Can beauty be found in the dark and grotesque? Should fashion reflect the times, rekindle the past, or be exclusively focused on the future? Is the creative process about experimentation, serious study, or play? Having a true north that orients you—and reorients you when necessary—will help determine goals and prioritize the actions that build your reputation.

True north is a constant but your relationship with it depends on where you're standing. Your position will shift depending on the direction your career has taken you. Being a rebellious designer is different when you are just starting out versus when you are the head of the company. Hard as it is, learn how to be an agent of change in your own career or business when it comes to your knowledge base, skills, and attitude. Advocate and facilitate course corrections as part of your process if you don't want to run the risk of becoming a relic of another time.

As a designer you must also remain true to your customer. Their feedback, how they engage with and interpret your brand should be strong indicators of the direction you should follow.

"I'm part of the fashion system, but I don't want to follow all the rules. I don't want to be contrarian—I just want to do my own things, which are most honest and correct to do."
Dries van Noten

The Opposition

The only way to understand the competition is to devote time and resources to doing some opposition research. Although the term has negative connotations because of how it has been used in politics—to discredit the other side—in this context, a designer can utilize the research to assess where the opposition's history, strategies, staff, products, and reputation are truly competing with their own.

After having identified and researched who you think the competition is, take some time to step back and look at the bigger picture. Industry rivalries may seem like the obvious place to start but competition can come from unexpected places. Burst the bubble and explore non-traditional competitors. Can they be found in other industries that are making fashion a part of their menu? Is your customer's most recent best experience the real challenge? Are you competing with your own history?

Once you have a good idea of what you're dealing with you need to frame the situation. Is your ego waging war? Are your biases keeping you from learning from the competition? Depersonalizing any perceived conflict will allow you to determine the best course of action.

Determine the arena you want to bring the fight to. Are you interested in setting yourself apart based on how bold, focused, or nice you can be? Will you be so disruptive it would be impossible to compete with you? Can you reposition yourself as a collaborator instead of an adversary, changing the conversation from "us and them," to "we?"

Conversations, Collateral, & Competition

Relevance
Be relevant. Don't speak to hear the sound of your own voice, and by the same token don't post for the sake of posting on social media. Is what you're sharing through any communication channel interesting, worth knowing, and apt to elicit a response?

The individual on the other side of the communication you've initiated is instinctively looking for two things. First, they want to know if and how what you're saying is useful to them. Will they have learned something or been provided with an advantage? Second, does what you're saying relate to them personally or professionally? If you've hit those marks you're more likely to keep their attention and avoid the greatest evil—boredom.

Don't forget that communication is a two-way street, even in public spaces like special events and social media. Listen carefully because people want to be validated. Restate what you've heard to reinforce the bond you're building, as well as to be crystal clear about what they've said. Resist the urge to be right because a conversation is not a competition.

The golden rule applies to any situation involving more than one person. "Ask unto others as you would have them ask unto you." If you were being interviewed, what questions would give you the freedom to fully express yourself? What stories would inspire you to respond? Why not make the effort to tell stories and pose questions that allow your audience to more fully reveal themselves to you?

Engagement & Empathy

Any strategy for engagement will need to include every touchpoint. There are multiple ways to correspond with your customer. What kind of material are you using to connect them to your brand? How is it delivered to them? When does it make its way into their inbox or mailbox? Which social media channels see the most engagement? Are they able to connect on the go via mobile devices? Does their customer service support their needs as expected?

After you've made initial contact the challenge becomes making the content something that they have an interest in consuming. Once they've watched, listened to, or read it, will it be understood and committed to memory? And finally, will it be something they are called to act on or share?

Setting the scene will increase the chance of sending a message that has legs. Consider how each of the senses is being engaged. Respect the amount of time involved in the interaction. Develop collateral that is unique and specifically designed to suit the delivery system, whether it's at the register, in the mailbox, at an event, on the street, or in a gift bag.

Exercising empathy will allow you to connect with your audience by way of the meaningful moments in their lives. How can your message be adapted to reflect the holidays and family events that they're celebrating or the life milestones that they're marking? Also ask yourself how you are rewarding their loyalty.

Moving Targets

Fashion can seem like it is in perpetual motion. This is definitely true of attention. In the competition for eyes and ears, keeping it short and sweet is a sound strategy. Brevity will address the limited time you have to make an impression and emotional intelligence will help the message resonate with their hearts. The formula does depend on a clear, concise, and easy call to action.

People themselves are also moving all the time. Not just about town, but from project to project, job to job, and around the globe. Being mobile friendly is essential. Besides making it easy to watch a video, RSVP to an event, or purchase a product online, mobile messages have the power to rally people in physical locations if there is a sense of urgency and a common interest.

At some point your target will stop moving. At this point long-form content should be available to enhance any initial connection someone has made with your message. While the fans of long reads make up a smaller percentage of most audiences, interesting video has the power to keep people's interest for longer periods of time.

If you want to stop competing for moving targets, dismiss the premise that everyone else is participating under. Choose not to chase and set yourself up on uncontested ground as the desired destination. It's harder to do but in the best-case scenario you become the target, with your audience voluntarily and eagerly moving toward you.

connection

Made In

The Meaning of "Made In"

Buying local has become a badge of honor for some fashion designers. Where something is made is of interest to their customers, and if the consumer is willing to pay more for the privilege, why not make it at home? Designers who are able to keep their business-to-business trade local, regional, or national are supporting those economies and using that fact to position their brand as a champion of the communities they work in.

Overseas outsourcing of the manufacturing process comes with its own set of issues and costs. Fair trade has become an imperative for any brand committed to fair wages, safe and healthy working conditions, reducing environmental impact, and building sustainable business practices. Although companies will always seek out the most financially rewarding choices, a greater awareness and demand for products that don't abuse people or the planet are making some domestic manufacturing a viable alternative.

Others strike a balance between the two by attributing the design to domestic teams, while acknowledging that the product is made on foreign shores. The compromise is meant to stress the caliber of design and the value they are passing on to the customer by manufacturing elsewhere.

The power of a "made in" label from a global fashion center has traditionally carried a lot of weight. The reason being that this label implied that those doing the work came from a long line of craftsmen from those regions with standards that reflected their reputations. That is changing dramatically because of an influx of workers from other countries, many of them being the countries that have been traditionally sourced for low-cost labor.

Local Global/Global Local

Small brands may consider developing a presence on the global stage. They'll need to find ways to become recognizable abroad and work out the logistics of exporting goods around the world. The transition into international trade is considerable. It requires an assessment of which markets are best suited to the product and whether those products will need to be adapted for these new markets. Language, laws, political policies, economic regulations will all present barriers to be overcome. Are you aware of and prepared to manage the kind of documentation required in doing business overseas? How will you protect your intellectual property and get paid? Globalism opens the doors to communication and trade, but that also means more competition. On the opposite side of the spectrum, large, internationally recognized brands realize that they must establish an authentic local presence wherever they set up shop, employing strategies informed by these communities.

Economically, it makes sense for any country's fashion industry to embrace a level of nationalism. At its best it becomes a strategy designed to protect domestic jobs as well as cultural identity. On the other hand, is it practical and profitable to bring manufacturing home, or a step backward, considering recent advancements in automation? Each designer needs to balance their civic pride with the limits it may place on global collaboration and cultural exchanges.

Being a global citizen doesn't require the rejection of a national identity but it does come with a responsibility to frame it within the context of moral, social, ethical, political, environmental, and economic issues that affect everyone on the planet.

Virtual Placemaking

More and more people are splitting their time between physical and virtual worlds. No designer should take for granted what can be accomplished in the latter. You need to meet people where they are—and, frequently, that's online. That's why a strategy for participating in or creating a virtual space is important. Virtual placemaking, like social media interactions, need to be planned, designed, and managed if you are going to harness the potential of digital communities. "Going live" has become second nature for digital natives. Live streaming and virtual hangouts are examples of interactive experiences that take place in real time and require some cultural competence.

Reality is relative when a designer can use virtual media to communicate and collaborate in a safe space that is conducive to the idea that anything is possible. Fantasy has the potential to provide more than an escape from the demands and restraints of the physical world if it can facilitate a new understanding of this artificial environment. While virtual reality has started off as a vehicle for entertainment, the fashion industry can use the platform to do market research, educate, and sell.

This new digital landscape also becomes a level playing field when content and shared experiences that were usually exclusive to the privileged few are now accessible to anyone. The increased reach of creative content has the ability to enhance the quality of life and economic opportunity for a customer, potential new hire, or student halfway across the world as easily as one living next door. It is also conceivable that the powerful trio of equity, diversity, and inclusion that empowers the participants of online experiences has the potential to manifest in real-life situations.

Landscapes Not Ladders

Stop Climbing
Climbing the corporate ladder is pretty straightforward: you get an education, you work hard, become a team player, dress the part, and network; you just need to excel, excel, excel. It must be said that following that route can be very lucrative. What they don't tell you is that it never stops—it's designed that way—and the only direction to go once you've reached what you perceive as the top is down, at least metaphorically.

Another advancement strategy is going lateral instead. Think landscapes, not ladders. Climbing the ladder usually involves someone being ahead of you and someone coming up behind you—quickly. Treating your career goals like the acquisition of real estate puts everything into play. It is no longer a matter of consecutive steps down a single path to success.

Companies are beginning to see the value of both types of employees. Those who are working within the system and those who have changed the terms of their role within the corporate structure and have some side hustle. If you want out of the vertical climb, your options include freelancing, negotiating a flexible schedule, telecommuting, or building your own business while getting a regular paycheck.

Some professionals rely too heavily on common but toothless idioms. Don't buy into false bravado. Stop saying, "Go big or go home" and "Failure is not an option." Sometimes big is just big, not better. And failure is always an option, as it should be: if you're sometimes not failing you're not trying hard enough, taking risks, or growing. These empty clichés become dangerous defaults that set you up for disappointment because they encourage unrealistic expectations.

"Be the designer of your own destiny."
Oscar de la Renta

Multi-Niche

Slash. Hybrid. Hyphenated. These are a few of the terms used to describe the careers of anyone with a mixed professional identity. One set of specialized skills is no longer enough to set yourself apart from the pack. In the same way that theatrical performers and sports figures are considered triple threats when they excel in multiple specializations, any fashion professional who demonstrates the same level of versatility is a highly prized resource.

The development of these meta-skill sets that lead to concurrent careers may stem from the places where education, vocational calling, special interests, natural talents, and carefully honed skills cross over. What used to be labeled as flaky, indecisive, or unfocused is now seen as a sign of motivation, high-level engagement, and adaptability. The change in perception goes further, valuing these individuals as creatively fulfilled role models.

These modern Renaissance men and women might also serve as a bridge between numerous industries. As a unifying force of seemingly incongruous combinations they are in a position to explore and define new frontiers, innovate, and invent. The same can be said for serial entrepreneurs who have been involved in the creation of different types of businesses.

The mastery of multi-niche skills can also future-proof your career. Beyond creating multiple streams of income, strategic choices may put you in a better position to work anywhere in the world, survive any economic climate, and create job opportunities you can age into. Writing, teaching, speaking, and consulting are transferable skills that are just as valuable in fashion as any other industry.

Improvisation
Working without a net can be one of the most intimidating things you can do in a professional capacity. So many of the things we've been taught about finding success are founded in careful planning and extensive preparation. Most of the time those strategies serve us well. Yet there are times when the art of free association will open you up to increased creativity and deep connectivity like nothing else can.

Finding the courage to go out on a limb is possible when you trust your own mind, let go of preconceived notions and judgments, are receptive to the possibilities that can be found in the unexpected, enter the experience without hesitation, have a willingness to start anywhere, and are brave enough to do something when you have no idea what will happen next. Scary stuff!

The best return on this brave investment will be the connections you make with others. Say yes to the situation, let yourself listen intently, be affected by what you hear, allow yourself to be changed, and focus on how you can support the ideas of others. This recipe for collaboration strips the power away from individual identities and feeds the idea being explored with that energy.

Remember that no plan means you can't get it wrong and that kind of daring will be rewarded. What feel like mistakes or missteps are merely twists and turns in the process. It's in this space where you can build things, make discoveries, and take risks.

Gear Shifts

When people look back on the trajectory of their career it's easy to pinpoint the moments that changed their course in profound ways. Predicting what those shifts will be, as you move forward, is not. That doesn't means you can't make educated guesses about some of the things that might force you to face major changes and repurpose your career.

Outsourcing jobs has been a big issue in the fashion industry and it shows no signs of slowing. There are many factors that lead to outsourcing but the most obvious relate to skill sets and money. What happens when your particular skill set becomes something that can done just as well somewhere else and for less money? What are you doing now to ensure that you're always ahead of that curve?

Progress is always a double-edged sword. Automation, fast approaching on the horizon, means millions of jobs in the fashion industry will eventually be done by robots. How does that scenario fit into your plans? What contingencies will you put in place?

How long before one or more of these things diverts your career? What about the impasse you can't imagine? Or the personal setbacks? No one is ever fully prepared for the unknown, but don't be caught out without having at least considered how you'll respond to shifts in the industry's timetable or yours. Staying informed is the most useful measure you can adopt to circumvent the doom and gloom associated with an uncertain future.

"Fashion never stops. There is always the new project, the new opportunity."
Carolina Herrera

Exits

Exit strategies are important and they are not always about securing a golden parachute. Knowing when to quit is not always clear when you're in the thick of it. What are some of the signs that it is time to move on? Are you still passionate about the work? Do you respect the process and the people? Is the job affecting your mental, emotional, and financial health adversely?

While burnout is very real, it is not uncommon to feel tired, overworked, and unfulfilled at some point in your career. It's worth taking steps to try to fix the situation before discarding a job or your whole career. Would a new direction reinvigorate you? Would a transition that involves learning new skills be an exciting proposition?

Get a head start in anticipation of when you'll be ready to make a change. Determine how much time you'll give yourself to make an informed choice. Be able to explain your reasons for the move in professional terms rather than emotional ones.

If you're starting over you could be putting yourself in a position that reduces your power and compensation. Prepare financially to make that adjustment as painless as possible. You'll also want to redefine your personal brand, activate your network, and partner with those who are moving in the same direction.

adjustment

8

ENGINEER YOUR DREAMS

EIGHT

Engineer Your Dreams

Fashion designers must be conversant in the new language of fashion: entertainment. Fashion has always enjoyed an element of theater but the stakes have grown exponentially over the years. While true fans are happy to simply admire and appreciate a designer's work, most want and expect more, much more. Consumers want to be charmed not only by the clothes but also by the experiences built around them. And although this is now the norm, engineering entertaining interactions is by no means second nature for many designers.

Preparing for these kinds of exchanges means acknowledging that an audience arrives with their own preconceived definition of fashion, just the way we do. Bridging the gap between the two depends upon how quickly we can communicate concepts, how authentically we interact with our audience, how specifically we are able to customize experiences, and in the end how captivating our performance can be.

grown

"Fashion is a language. Some know it, some learn it, some never will—like an instinct."

Edith Head

Fashion Myths

Mythos

The stories we tell ourselves are important. These narratives help us figure out what we believe in and end up influencing the choices behind every creative act and every professional move we make. Early in our careers we try many different myths on for size. Over time we adopt the fragments that fit until we have enough to weave together a story of our own to share with others.

Myths with a heroic figure at the heart of the story can rouse our imagination and drive us forward at the times when we're most in need of motivation. They keep us going because we can project our potential onto the idealized version of their story. Who are your fashion heroes?

Intentionally or instinctively you will be looking for direction throughout your fashion career. This is especially true when a designer is inventing or reinventing themselves. Look for clues in the histories of fashion houses that have had a reversal of fortune, or fallen out of favor but been able to reestablish themselves in the industry.

Legends provide us with comfort and hope. They become stand-ins for what we don't understand or haven't yet been able to achieve—the overnight success that was actually 20 years in the making. They become symbolic examples of how what seems out of reach is attainable.

"The creative act is not hanging on, but yielding to a new creative movement. Awe is what moves us forward."
Joseph Campbell

dangerous

Myth Busting

As a designer you will encounter many myths that merit being challenged if not altogether debunked. In the interest of projecting an air of authority, some fashion professionals will take advantage of assumptions made by consumers or the public. Some of these fashion myths have been inherited while others are well-packaged attempts to make a sale. Designers and consumers alike need to decide whether or not so-called fashion "rules" are relevant to the clothes they make or wear. Why can't you combine different prints? Who says you can't wear black and navy? Or black and brown? Must your bag match your shoes?

There are also myths about the industry. Contrary to popular belief, not everyone who calls themselves a fashion designer can actually make clothes. Fashion is definitely not all glamour all the time. And while catchphrases can be fun, phrases like "you're either in or you're out" may be true in finite circles of influence, but the industry is vast and diverse enough for more than one narrow view of fashion to succeed.

When it comes to making value judgments, new may make for more interesting copy but it does not mean better. The traditional idea of luxury is also a myth. It is no longer about a high-end price tag now that experiences and exclusivity have become the currency of a luxury lifestyle. This also means that you don't necessarily get what you pay for if you're trading in old ideas.

Perhaps the most dangerous myth of all is that you should follow your dreams. It's terrible advice. Dreams are wonderful things but you don't want to relinquish your power to be passively led around by them. Please stop following your dreams. Start preparing for them instead.

personality

Myth Making

There should always be a good origin story behind every fashion designer. How do you differentiate yourself in the hearts and imaginations of your peers, the media, and your clientele? They want a story that they can retell, so it should be unique, dynamic, and easy to remember.

What is your narrative? Are you the hero of your own story? Even if you're just starting out, does your story explain how you got to where you are today in a compelling way? It should be more than a chronology of life events. There needs to be a strategy behind how to frame the tale and how to tell it if anyone is expected to care.

How does your personality factor into the telling? Who were the people that challenged you? What were the events that shaped you? What lessons did you learn along the way that could make a difference in someone else's life? Is the tone epic, adventurous, or humorous? Also remember that happy endings are just a matter of where you stop the story.

While nothing in your story should be untrue, ask yourself what part of your story leans toward the legend? Is there a way to spin it that makes the familiar a little more fantastic? It's not a matter of fabrication or even embellishment. Your perspective means your interpretation. Often underselling yourself or overcompensating is a sign that you're not having enough fun sharing your own story.

> **"Fashion in the past meant conforming and losing oneself. Fashion in the present means being individual and finding oneself."**
> Gloria Steinem

170

Style Shorthand

Symbols

There are powerful ways to communicate without ever saying a single word. Non-verbal tools allow a designer to share their vision without having to explain it. These mechanisms need to be carefully designed like anything else. Logos for instance can be created using recognizable alphanumeric symbols expressed through typeface, color, and orientation or be developed as original marks that mirror the brand's essence. The development of a logo should also take into account how it will take shape as a three-dimensional form.

The spaces you show your clothes can be used as life-size symbols or extensions of a concept, which someone can physically immerse themself in. The intensity or lack of light, the size and shape of the room, acoustics and surface textures can make or break an environment. In a controlled setting, color, which may have once helped punctuate a design detail, can now envelop an audience completely.

The experience of a special event, fashion show, or shopping trip has the potential to become a visceral memory if the participants are stimulated, preferably in a positive way. Technology allows us to record every moment for posterity, but there is no substitute for being in the room. A shared response to content generates a unique energy, impacted by elements that cannot be captured on video. Bear in mind that much of the time there's a fine balance between getting it right and getting it very wrong. A long line has the same potential to frustrate guests as it does to build their anticipation. Music selections may elicit strong emotions, while the volume could undermine the ability to enjoy it. The pace of the performance can make time fly or feel like torture. The amount of personal space allocated to each individual is another important consideration.

The symbolism of a person, whether it's the designer or another representative, is not to be underestimated. They are living breathing embodiments of the brand. Their physical attributes, tone, gestures, and expressions are as much a part of the message as great graphics and clever copy. In the wrong hands meaning may be misinterpreted or altogether lost.

Message

Designers are responsible for every message they deliver, whether that is in the workroom or on the sales floor, on social media, or in an interview. Messages usually fall into one of four distinct categories.

Those with a positive charge are designed to acknowledge, confirm, and be of use. Because they are helpful in nature the expectation is that the recipient will be receptive to it.

The purpose of negative messages is to deliver information that someone will not be eager to hear. Warnings, reprimands, controversy, and rejection are unavoidable in both the creative and business sides of the fashion industry. The question is how to deliver unwelcome content. On a case-by-case basis you need to decide whether building a sense of optimism into the message will make it more digestible, or whether it will be better received being quick and to the point.

Neutral messages are a simple matter of sharing information in the interest of education or creating a level playing field. Persuasive messages, whether obvious or unintentional, appeal to logic and emotions using positive reinforcement or by leveraging fear and anxiety to change minds. In fashion, a compelling communication is designed to convert casual observers into devout followers and those followers into loyal customers.

compelling

There are details that need to be taken into account once the type of message has been determined. How will the intended recipient influence the tone of the message? Will it be formal or informal? How will the delivery device—face-to-face, print, or digital—impact length? If the message is one in a series, how will they build on each other? How will the timeline and pace make the most of each release?

Purpose
In order to avoid having any initiative fall flat, intent needs to be built into everything. Only then will the brand have the potential to make an impression. The primary purpose should always be identification. Being able to identify a brand or the work of a designer quickly and effortlessly is the ideal result. With established brands it is a matter of recognition. For a newer player on the fashion scene the challenge becomes how to fly their colors and build a tribe around them.

Once your audience has been engaged your efforts should be informed by their desire for authenticity. The goal becomes how to inspire, motivate, build trust, and retain their interest. At this level of engagement, language in all its permutations—imagery, action, the written and spoken word—must never ring hollow.

The last stage involves empowering the community you've built and allowing them to carry your message forward, each in their own way. When they adopt the symbolism they rally around they can become a part of it. Their purpose becomes intertwined with yours and communication flows two ways. There is no more authentic and direct source of information than that kind of dialogue.

Interactive Storytelling

Creative Direction
Designing the structure of an entertaining story—photo editorial, video, fashion show, or special event—requires that every element supports a single cohesive vision. While fashion designers are often the source of that vision, discerning between design, art direction, and creative direction helps to clarify which responsibilities are the focus in each role—even when they fall on the same person's shoulders.

Designers are responsible for creating a collection that reflects the season and needs of the consumer. Art directors ensure that all the aspects of a fashion show conceived to present that collection work in concert. The person responsible for the creative direction of the brand is tasked with making certain that both the collection and the show measure up against brand standards.

The reasoning behind storyboarding for film or television can be applied to all manner of fashion storytelling. Every detail is scripted and timed. Big narratives can be broken down into scenes. Choreographing movements and the precise sequence of every cut, pan, tilt, wide angle, and closeup helps further break down scenes and smaller stories to keep everyone on the same page.

Large creative arcs in a designer's career can be handled like long narratives that are told over multiple seasons. When the time is right to move on to new stories these new offerings can be treated like sequels or spin-offs depending on how closely they rely on what has come before.

Writing! Writing! Writing!
In the event that the clothes do not speak for themselves, some well-crafted writing will come in handy. In fact there is a long list of communication tools that require strong writing skills: résumés, bios, correspondence, creative statements, product descriptions, press releases, social media posts, captions, blogs, articles, and books to name a few.

Regardless of the platform, root your writing in research that goes deeper than superficial first impressions. Being able to see things from multiple points of view also adds to the quality of your writing. Taking up the habits of a good journalist—thinking critically, being organized, objective, observant, and curious—will produce honest, straightforward content when you are in report mode.

Telling a story requires more than just running through the facts. In this space writing can be colorful, coded with hidden messages, and even provocative when the situation calls for it. Writing also needs to be pointed in the right direction. Employee or consumer feedback are examples of upward communication. Top-down language in the form of orders or instruction should convey a sense of power. Attempts to coordinate efforts among peers would be described as sideways communication, and the mode will depend on what you are trying to achieve. And then there are the times when what is being written needs to strike a chord on multiple channels.

The ultimate goal of writing is to create and deliver valuable content that resonates with the reader. Being open and able to edit your material will also help develop a recognizable style, so write and revise regularly. As Cristóbal Balenciaga is credited with saying, "Elegance is elimination."

Next-Generation Narratives

Customers are getting more demanding. They want what they want, when and how they want it. Every entertainment channel is responding to their appetites. Storytelling does not have to be a passive linear exercise, it can be an activity to engage with. One that welcomes, and even needs, your active participation to move forward. The collective effort includes the designer who sets the premise, technology which provides many of the platforms, a storyteller who facilitates the telling of the story, and the audience.

Transmedia storytelling is the building of that complex puzzle. This involves letting go of linear narratives and enough control to allow the action and the outcome to be informed by everyone involved. Every brand has a rich resource of content that can be tapped at any point of the development of a collection. Stories can be told about the evolution of a concept, the making of a collection, or the thinking behind a business or creative strategy.

Designers produce live theater experiences—the fashion show. These are designed to entertain an audience in real time. Think about ways the single story of a collection can be enhanced and expanded. What if someone watching the livestream could take control of the camera feed to switch back and forth between different vantage points? What if you could watch behind-the-scenes videos of the making of specific garments in the collection, or follow a model's experience at the casting, fittings, and backstage for the same show on social media?

Every platform and every perspective provides an entry point for extensions of the story. In addition to telling more stories, these extensions can become tangible revenue streams themselves—think accessories, apps, books, video or music downloads, memorabilia—otherwise known as merchandising.

Niche User Experiences

Channel Surfing

A large percentage of the public is engaged in perpetual channel surfing on media channels and in the real world. Mobile phones are the ultimate remote control, allowing us to click through channels until something is worthy of the attention that couldn't be kept by who you were with, where your were, or what was taking place.

So what is the right mix of channels that we need to have a presence on? Website and social media, along with search engine optimization? Marketing, radio, print, direct sales, and advertising? Events, sponsorship, community involvement, and donations? Instead of fighting the fact that your audience is jumping between channels you can put that to good use. Establish a presence in both expected and unexpected places. Create demand and a fear of missing out by narrowing the focus with exclusive, invite-only events. Co-create content across platforms, industries, and locales.

There are two camps in terms of how to build a presence on those channels. The first involves instant gratification and relies heavily on spectacle or positioning yourself as a curiosity—the never-ending quest to go viral, or the attraction of reality-television notoriety. This approach has proven that it can get you buzz but it usually has a short lifespan and by nature is disposable.

"Look at the way sports, music and film have become driving forces of popular culture. Fashion is the fourth pillar."
Imran Amed

On the other side of the spectrum, creating content with a longer lifespan means that rewards may not be as immediate. Sustained attention usually translates into meaningful engagement. If you're careful and clever, you could manage to land somewhere between the two and make good use of what both sides have to offer.

Custom UX

The most personal level of a customer's user experience can found in the garment itself. It takes the form of a secret shared between the designer and the person wearing it; something as simple as a luxurious lining that only the user comes into contact with, cleverly hidden pockets, or a vital function rendered invisible by the design.

Some designers will personalize designs or tailor encounters for the customer based on feedback and the history of their interactions with the brand. They find ways to enhance the experience, make them location-specific, reward loyalty, and make recommendations.

Designers may also put the tools for customization of a product or an interaction in the hands of the client, giving them explicit control over elements of its design. Apps that automate custom design, shopping, or the sharing process work best when they're balanced with exceptional customer care.

Seamless UX requires the collection of a lot of information, open communication channels, attention to detail, constant testing, monitoring, analyzing, and adapting. It's the only way to eliminate irrelevant barriers to a positive experienc,e as well as anticipate any needs or desires that aren't served by the prescribed design. Remember that one size doesn't often fit all and even when it does we will rarely be averse to being treated to something a little special.

Guest Platforms

Part of entertaining is having a persona that can serve as a focal point or provide a voice that people will follow. To do this that figure needs to be visible and seen by as many people across as many platforms as possible. This goes beyond speaking engagements and panel discussions because a mastery of their own field is to be expected. The ability to put their creativity, voice, and vision into the service of other disciplines elevates them to expert if not star status.

Being invited to take over a social media account allows a fashion designer to share how they see the world. Even when "a day in the life" exercises take place in front of large audiences, there is great value in the sense of intimacy inherent in the platform.

As a contributor to a media outlet or in the role of guest author of a popular blog, the relevance of a designer's voice can be established when it holds a place among other respected professionals. Taking temporary command of a prestigious publication in an editor's capacity allows a designer to interpret their creative direction for a different audience on a larger scale. Any successful undertaking of this kind helps cement their position in the industry as a powerhouse influencer.

blog

Showmanship

Entertainment

The concept of the fourth wall in fashion has traditionally been used to keep designers, the media, and the consumer in their respective places. Everyone respected these unspoken boundaries until that wall came down. Blurring those lines has recast the spectator as participant, with much of the access that implies. Fewer audiences are taking part in the passive pastime of simply being entertained. They want to feel like they are part of it, because they are.

The soundtrack of every show and special event is extremely important when you consider that most people carry around several hundred if not thousands of songs carefully sorted into personal playlists. Why wouldn't they expect that same thoughtful consideration be given to the music they will be listening to at a show? Some of the most interesting results develop when fashion designers collaborate directly with musical artists.

Regardless of the venue, grand or grungy, successful show environments depend on well-defined production values and meticulous management. The designer-as-entertainer requires a plan that appeals to all the five senses as well as a sense of place.

Fully immersive experiences must be sustained for their entirety whether that is a brief or extended amount of time. Scale can be a big part of conveying the essence of theater. Sets, lighting, sound, accessories, footwear, makeup, and hair are just a few of the choices that can be magnified for effect, even if the clothes are not aesthetically extreme. The overall impact is a key contributing factor in the making of a memory.

runway

Fashion Shows

Fashion shows were not originally intended for the general public. Designers presented their collections months ahead of when they were scheduled to be hanging in shops because buyers and the press required that lead time to do their jobs. Although technology has shortened production turnaround times, the fact that the industry has been cultivating the public's insatiable desire for spectacle and the next new thing has created a great deal of confusion. In spite of having been responsible for it, the industry has been slow to rethink the strategy behind having a show aimed at the masses. "See now, buy now" is a model that allows consumers to indulge a need for immediate gratification by purchasing in-season goods they've just seen on the runway.

"Out of sight, out of mind" applies to all your customers who aren't on the guest list. Share a link to a show that is live-streaming and all that changes. In a click you have granted access to anyone with an internet connection, allowing them to join a global army of armchair buyers and desktop fashion critics.

In addition to high-visibility offerings designed to create a buzz and stimulate sales at the consumer level, fashion houses may also choose to host industry-only presentations earlier in the timetable. This type of show would mark a return to a time when a designer could control the dissemination of information and better serve the demands of doing business.

It seems that every major city in the world now has some version of a fashion week, and there are regional, category-specific, retail-oriented, and social-set incarnations to be found everywhere. The allure of fashion's promise is hard to resist. Those who stand the test of time usually reflect the needs of the cities they serve, sometimes redefining what a week of fashion programming should include.

"Fashion shows are really my way of communication."
Dries van Noten

Instead of Shows

The cost of fashion shows may be prohibitive for many designers. This has spurred on a creative surge of ideas regarding how to share the fruits of their labor with an audience. Fashion films have become a popular outlet, allowing designers to direct, edit, and project their vision for posterity. Even short films require a great deal of planning and hard work to get right. But once it's in the can, it's done. A film is also easily distributable. The red carpet glamour of a screening can prove just as exciting as a live show and it allows contributors to the project the ability to interact with their audience comparatively without stress.

Installations, on live models or mannequins, are all about the details. They afford guests an alternative to getting glimpses of models rushing down a runway. It gives them the chance to get up close and personal with the garments. Good lighting and an interesting space are invaluable aspects of this intimate, highly personal experience.

Contrary to popular belief, print is not dead. High-quality paper stock has become the medium of choice for creative content deserving of the expense. For connoisseurs, nothing beats the look and feel of something produced well in a magazine or art-book format. These volumes can become collectible works of art in and of themselves, albeit costly ones. That is why digital versions are important too.

A less formal but decidedly more provocative way of grabbing people's attention is the stunt. Fortune favors the bold in this format. Being able to deliver the wonderful, the mysterious, the funny, the risqué, the ridiculous, or the strange in unexpected places at improbable times is a recipe for shock and awe. It is crucial however that designers make sure that stunts don't stray far from the ultimate goal of connecting with the consumer.

NINE

INITIATE INNOVATION

Initiate Innovation

The fact is that no matter how prepared you are, you have no idea where your career will actually take you—there are too many variables. The good news is that solid fashion training provides you with skills that are transferable across many different disciplines. Some that you haven't been exposed to and others that haven't been invented yet.

While planning for the unknown is all but impossible you can take a proactive role in creating a climate in which you will have the tools, experience,s and mindset to innovate and meet the future head on. Some key components of that strategy include breaking down the silos that separate different disciplines, collaborating to investigate new ideas, exploring the potential of new frontiers in science and technology, building relationships with the cultural sector, cultivating a professional conscience, and preparing for the jobs that don't exist yet.

future

"Where do new ideas come from? The answer is simple: differences. Creativity comes from unlikely juxtapositions."

Nicholas Negroponte

Linking Silos

Comfort Zones

Certain places, people, and ways of thinking and doing things make us feel safe because they are familiar. While safe is important, there is a problem with familiar: not much innovation happens there. Getting out of your comfort zones is necessary if you want to innovate. Each person's comfort zone will be different, but here are two pieces of advice that apply to most people:

Travel beyond your professional borders. Meet people who are not in your social sphere. Be aware of your thoughts, and learn how to redirect them. Be brave and commit to doing different things differently. Update the why—the reason why you're doing something. Ask yourself, "Why are you doing this, now?"

Let go of expectations. Trade them for an enthusiastic curiosity about the outcome. This might be the hardest thing to do because being results-oriented is a part of doing business. However, the ability to do something for the sake of doing it is an opportunity for growth.

The machinations of the real world may preclude these shifts in thinking from being applied to every situation but it should definitely be a part of a designer's approach to the creative process. Far from being meaningless, disrupting the flow of your regular thoughts can be a liberating exercise in expanding the boundaries of who and what you are comfortable with.

Cross-Industry

There are many advantages to cross-industry collaborations. Where co-creating with peers can get a little competitive, working with contemporaries that represent other industries is by nature interesting and informative. The landscape of opportunity is vast when nothing is off the table.

Sister art and design disciplines are an obvious place to start to look for collaborators because of the common language. In addition to textiles and industrial design, they include visual and multimedia arts, art direction, curating, merchandising, media channels, and advertising. Creators of residential and commercial spaces—architecture, interior design, landscape design, lighting design, urban planning, and set design provide other domains to explore. Entertainment, performing arts, and UX design offer insights into the communication aspects of design, as do animation, web, and game design.

Designers may also choose to blur the boundaries between fashion and industries with completely different attitudes and objectives. Alliances with sports, medicine, government, food, and travel are full of unexplored opportunities. Partnerships with academic institutions link education, research, and innovation—the knowledge triangle—a useful tool for building products, integrating networks, generating policies, developing programs, and job creation.

The courtship between these entities can be initiated by a student, a designer, or a company as a way to jumpstart projects. After the initial outreach or introduction, both sides should explore differences and commonalities to determine where trade-offs will be made and where the alliance will be mutually beneficial.

Co-Creation

Implementing the co-creation process with partners that have different perspectives can be a challenge. If the connection is complex there may be too many issues to compromise on. If it's too simple the whole idea may be overkill. The ideal symbiotic ecosystem will have clear goals—individual and shared—that serve as touchstones throughout the process.

Partnering for profit is straightforward enough but not all fact-finding missions need be commercially motivated. Working together on a research and development project can be a valuable exercise in its capacity as part of a larger objective. Big projects may call for multiple collaborations as a way to conduct platform-specific outreach and experiments to collect data and experiences.

The goal of coming together may be in the interest of merging teams and building audiences. In addition to increased numbers, it can be a way to introduce greater diversity into the mix. A variety of perspectives allows everyone involved access to alternative ways of seeing, thinking, and doing things.

The framework of a collaboration can be built around different types of projects or events. Co-brand a product. Co-write an article or book. Co-teach a class, or facilitate a workshop together. Co-present a fashion show. Co-curate an exhibition. Co-produce a photo shoot or special event.

"Fashion has a long interest in collaborative situations."
Raf Simons

profit

The Lab Mind

Experimentation

Rigorous investigation may seem like a surefire way to strip the creativity out of the creative process, but it doesn't have to be. Critical thinking will help you determine what to follow through on, as well as when and how you're going to move forward. Any information that increases the chances of success in those areas is worth the time it takes to collect and understand it.

The more objective the findings of an experiment are, the better the analysis. Unbiased evidence often raises unexpected questions and leads to unpredictable challenges. Sometimes that means a setback, requiring further examination. Other times it will serve as a catalyst for innovation.

Whenever you evaluate something with a healthy does of skepticism, the subject of your inquiry could come into question and be redefined—something you once thought was meant for one market is recategorized, for example. You may not realize how prejudices or preconceived notions about your own work might be limiting the markets you could be successful in.

Defining a project as a pilot program allows you to establish criteria and set standards that can be tested and retested in the hands of the consumer. Misfires and malfunctions inform how to improve the product or service. The level of trial and error involved also helps assess the feasibility of the project overall.

unbiased

Iteration

Getting things right the first time round is not the road to innovation; that's just luck and you can't count on it. It also shows a lack of respect for the time it takes to master something. Sometime you need to improve before you innovate. There are different things to learn from versions 2.0, 3.0, 4.0, etc.

The focus of the initial iterations of any project should be quality. These first few versions provide you with the time you need to understand the nature of what you're doing. Don't shrink from the challenge to repeat the process until the result is something you can be proud of.

An investment in repetition will allow you to build up speed so that you're able to have quantity as well as quality. Throughout this phase, economizing on time and materials will stem from an interest in refining the process rather than a desire to take shortcuts.

Perhaps the best dividend of iteration is the muscle memory you build up along the way. It may present itself as better hand-to-eye coordination or the ability to anticipate and respond to circumstances more efficiently. "Wax on, wax off" becomes second nature. Thank you, Mr. Miyagi.

process

redefine

Failure

Wrong turns in fashion suffer from extreme magnification in the moment but they do set you up for a comeback in the next cycle. Take advantage of the time in between to redefine your relationship with failure because it correlates directly to future potential.

Always steering clear of any thought or activity that could result in a failure will erode opportunities for innovation. Reprogramming your responses to disappointment requires time and patience. Protect your confidence by distinguishing yourself from your work. Avoid the temptation to fall back on those things that you already do well and be brave enough to attempt projects where success is not guaranteed.

Failures are always moments to learn from. You should never not be learning but it takes a concerted effort to put yourself in student mode. Learn all you can about your decision-making process, the materials you're working with, your team, and the consumer you're selling to. Missteps take you into uncharted territory, and with that comes the invitation to begin a process of discovery. Explore every avenue to invent.

Instead of just tolerating mistakes, an open mind will permit you to interpret them as happy accidents. Unexpected good can be found in situations that didn't go according to plan when you're able to look past the your original intent. Failures also serve as a natural process of elimination. Knowing what doesn't work is as useful as knowing what does.

"I prefer imperfections— they're more interesting. Perfect is boring."
Grace Coddington

New Frontiers

Science
The physical, life, social, and applied sciences have historically been a large part of innovation in the fashion industry. Advances in the fields of chemistry, biology, human behavior, and computer science are responsible for significant changes in materials, methods, attitudes, and communication.

Collaborations between fashion and science touch many aspects of contemporary lifestyles—travel, sport, health, and wellness. In addition to tangible contributions, the sciences also inspire new ways of expressing the aesthetics of fashion. The history of making dyes, for example, has and continues to evolve in terms of access, safety and variety, thanks to its relationship with chemistry; as has that of fabrics, fibers, and other materials used by the industry. Fashion has begun to tap into biology to engineer organic materials that can mimic limited natural resources, respond to body temperature, perspiration and odor, build in a sustainable lifespan, and filter waste in attempts to protect the planet.

Social sciences help a designer understand their relationships with consumers and society as a whole. The engineering of textiles allows manufacturers to weave responsive performance properties into fabric, while computer science continues to transform how fashion is created and consumed.

"I was never so directly inspired by fashion. It always came from somewhere else."
Helmut Lang

virtual reality

Technology

Machines that make use of robotics, 3D printing, and laser cutters have begun to integrate the various manufacturing processes—weaving or knitting, cutting, pattern-making, construction, and customization. Advanced looms are able to produce fabrics that self-heal, self-clean, change color, collect solar power, or display magnetic properties. Tech-enhanced wearables make communication and game play an integrated part of a wardrobe.

Artificial intelligence is a concern for a lot of people. In spite of the fact that machines can now be fed information and opinions about color, texture, style, and trends that are then filtered through algorithms to stitch together ideas for clothing, fashion designers should not be concerned about being replaced. If they learn to use this technology as a tool, they can be more adaptive and responsive to the market.

The dressing room is the first and sometimes final gauntlet to be survived in the retail experience. It makes sense that it has been one of the first environments in fashion to be explored for its augmented-reality potential. Virtual dressing rooms can be online simulations that allow the consumer to use an avatar to try on clothing, or physical spaces that project virtual garments onto their reflection.

Virtual reality is a new platform for experiences that can drive commerce and design. Marketing to consumers, producing fashion shows, and shopping can now be a completely virtual and portable experience. This realm allows the designer to design in three dimensions and create fully interactive portfolios.

Social

"Social" is easy to take for granted if you're living it. Design, business, advertising have all been socialized. Unless you can dedicate considerable manpower and money to taking the maintenance and interaction that commercial socialization requires off your plate, you'll need to think about how you can curate and execute it yourself.

In a global omni-channel world, designers need to craft messaging and manage two-way streams of information while making it all feel like a personalized on-on-one experience for the recipient. If it's going to have any chance of disrupting the field the plan has to be flexible enough to keep up with inevitable changes across the board

Identify the devices du jour and ensure content takes advantage of upgrades and new features. As new social platforms are introduced or expand their offerings, their audience and that audience's means of and reasons for engaging the service need to be understood. Pre-commerce is an example of a new platform changing a well-established business dynamic; putting the decision of what goes into production into the hands of the consumer.

The rules of engagement, as they reflect the brand and different platforms, need to be spelled out. A social strategy for digital and real-world business interactions needs to be mapped out over internal and public timelines.

mapped

Culture & Conscience

Culture

When a designer knows and understand the origins and aspirations of their audience, that designer is in a better position to appreciate where their customers live—physically, intellectually, and emotionally—in the present. A designer can draw on the bank of human knowledge, customs, social interactions, and cultural capital—literature, performing arts, visual arts, entertainment, games, gastronomy, sports, human studies, and celebrations—to set the stage for innovation.

A designer's cultural reality may not be their customers'. It becomes a subjective term when it is determined by the lens you are looking through. How someone defines themselves through ethnicity, class, and gender permeates every aspect of the lives they lead. Does their identity elevate them to a social elite or relegate them to low cultural status?

Culture also strives for the ideal. The arts are physical expressions of that search. That ideal might be sought after in the protection and pursuit of the intercultural or multicultural, folk cultures, countercultures, subcultures, and even corporate culture.

The cultural assets we produce and consume—pop culture, goods, services, athletic and leisure activities—show how culture can be folded into society. What we believe in—politics, religion, tradition, a way of life—represents non-material but very powerful cultural influences.

"One thing that I always liked about fashion was that it was tied in with music and art and film."
Tavi Gevinson

culture

Conscience

Changing minds is a matter of making sound rational arguments. The alternative needs to make sense. Is the product of it easy to find? Does it look good? Is it reasonably priced? Is it reasonable to expect change in our time? For our children?

Making the "good choice" needs to feel good too if you're going change hearts as well as minds. Protecting people you don't know from abuse, mistreatment, or violence is a noble motivation. Thinking of every choice as an investment in the future feels like a benevolent act.

Education is at the core of changing behavior. Demonstrating the impact of every purchase with something like blockchain software could change the narrative. As ingrained as materialism is, it can become counterintuitive when the behavior is made accountable for its destructive influence on society and the planet.

Ultimately growing consciousness within the industry and in the marketplace will involve appeals to some very basic tenets of self-interest—aesthetic values, peer acceptance, budget concerns, and a measure of vanity. It may also be a top-down transformation, when surprising validators grant others permission to act on what they already know.

Environment

The biggest threats to the future of the planet and its inhabitants are prime places to start thinking about responsible innovation as it pertains to improving conditions. What would a revolution in the fashion industry look like? How do you educate consumers and cultivate consciousness across the board? What do you tackle first? How do you coordinate efforts to address the many different challenges? And then there is the bottom line. How do you make it profitable?

Concerns about the ecology and energy consumption can begin to be addressed by redesigning the fashion pipeline so that it is more efficient, protects natural resources, slows down production and consumption, stresses low impact in the construction and care of clothing, and makes strides in the detoxification of the current system.

Investments in the development of new fibers and recycling technologies are ways to address the tremendous issue of waste. Attention should also be paid to waste collection, sorting, and disposal. Designers and consumers might also begin to build a relationship around resourcefulness—upcycling, downcycling, and the repair of products and materials. Designers should avoid and consumers should be aware of greenwashing, the attempt to project an environmentally friendly public image when their practices don't back up the rhetoric.

Putting a face to the forces behind manufacturing products helps inform and govern how business is conducted in the fashion industry. Ethical thinking asks, "Who makes your clothes?" It motivates you to establish standards, practices, and transparency for labor. Respect for the human component, their safety and basic needs, also encourages professionals in the fashion industry to seek out opportunities to work with underdeveloped countries.

The Jobs that Don't Exist Yet

Get S.T.E.A.M.D
Education has been stressing S.T.E.M. (science, technology, engineering, and math) programs in the interest of providing their students with a competitive advantage as part of the future workforce. Arguments have been made that the arts need to be represented in that mix: S.T.E.A.M. Others take it a step further adding a D for design. It may seem to be getting more convoluted to some but the truth is that if we're trying to prepare the next generation for jobs that don't exist yet they can't be getting a one-sided education.

Designers may not need to know the molecular structure or chemical composition of a material they're using, but a fundamental understanding of chemistry will help them find uses for it that a scientist could never have envisioned.

Technology of all kinds has already been fully integrated into every aspect of creativity and business, making coding the new language of fashion. Engineers and fashion designers share the challenges of usability—structural limits, ergonomics, and the seamless integration of technology. The study of mathematics is a must for financial literacy, and you cannot draft a good pattern without it.

Some designers, being fluent in art and design, think that they have dodged the need to also be conversant in S.T.E.M. subjects. Nothing could be further from the truth if they have any interest in being a fashion innovator because these skills are the gateway to new jobs.

"A new language requires a new technique. If what you're saying doesn't require a new language, then what you're saying probably isn't new."
Philip Glass

envisioned

Indicators of Innovation

Recognizing and measuring innovation is a crucial part of communicating its value and leveraging its power. Numbers are the most obvious sign of a growing culture of innovation at a company or in the marketplace. Are new products, platforms, and services being introduced on a regular basis?

A company that values knowledge is sending a strong message because they put their money where their mouth is. What percentage of the budget is being allocated to research and development, new hires, and training? Is the investment in knowledge attracting media attention and showing an increase in consumer spending?

In addition to institutional changes, are policies changing? Immigration is a prime example of an issue that has to walk the line between local and global concerns. Are the choices being made in your company, community, and country reflecting its level of receptiveness to the idea of innovation?

Innovation is disruptive. It creates paradoxes and concerns. How is your audience changing in terms of demographics and behavior? How are they managing the influence of innovation on their personal and professional lives? Is increased interconnectivity bringing them together or dividing them into smaller and smaller tribes?

Unknown Variables

The innovations that have yet to surface are the ones that are creating the great unknown in your future when it comes to getting work and clients. The first thing a designer needs to do is build on core competencies. Employers are looking for the whole package, and have a pretty good expectation of getting it with so much competition in the job market.

In the same way that businesses lose money in their first few years because they are investing in people, research, infrastructure, and technology, the start or reinvention of a career demands the same kinds of sacrifices to put all the pieces together. The collateral: recommendations, results-oriented résumés, comprehensive portfolios, a digital presence, and clippings. The qualities: flexibility, confidence, emotional intelligence, a solid work ethic, a learner who can absorb new information and integrate it quickly, and certificates in other fields. The experience: internships, data and statistics, public speaking, presentations, leadership, sales, travel, and more general life experience. The packaging: good grooming, the right wardrobe, a practiced voice, and multiple languages.

Part of preparing for the unknown is knowing that there will be setbacks. Staying positive when things don't go according to plan is easy to say but having thought about it beforehand makes it easier to do. Are there projects that can keep you busy and on the radar? Have you maintained and continued to increase your network? It never hurts to always be thinking about setting up and maintaining multiple income streams even if they're not industry-specific. Have you prioritized the cuts you'd make if you have to reduce your cost of living? Do you know how you'd go about deferring student loans? Is moving back home or relocating an option? If you had to broaden the parameters for a job search what would it include?

Always be innovating you.

Index

Acknowledgments

This book is dedicated to my students—past, present, and future—because I learn as much from you as I try to impart. This book stems from a genuine desire to see you succeed.

First, thanks to Ms. Sweet. Isn't that the perfect name for the toughest teacher I ever had? She played a vital role throughout my first years of training at the High School of Fashion Industries in New York. Even after all these years she lives on vibrantly in my memory as a reminder of how important it is to respect the creative process, work smart as well as hard, and always be a person of your word.

I would also like to express my gratitude to everyone at the School of Fashion Design and throughout the Boston fashion community for their part in creating sa vibrant environment to work in.

Thanks to Zara for the opportunity, my editor Rachel for her keen eye, enthusiasm, and encouragement, and the whole ILEX team for designing a book that I am very proud of.

On a personal note, thanks to Mom for your daily texts, Dad for the jokes, my sisters for all the sweet updates on my nephews and nieces, Richard for always being there for me, and Zak for being a source of inspiration and hope for the future.

And last but not least, a very special thanks to my champion. Thank you Robert for your boundless patience and unconditional support—always.